PSYCHOS

THE STORY OF THE
PSYCHO FILM FRANCHISE

By Christopher Ripley

Editor: Jan Davies
Layout & Cover Design: Emily
Additional Research: Kate Morgan
Special thanks to
Universal Studios' Archives and Collections Dept.
ISBN: 978-0995536227
Address any queries to eskdalekent@gmail.com

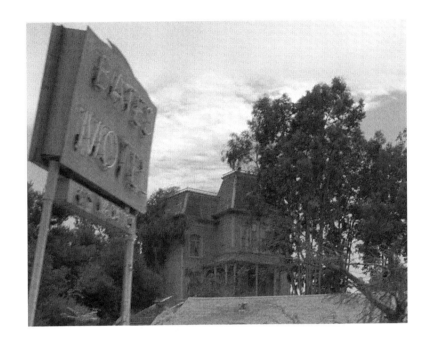

"This paperback is very interesting, but I find it will never replace a hardcover book - it makes a very poor doorstop..."

Sir Alfred Joseph Hitchcock KBE, January 12th 1960

CONTENTS

ACKNOWLEDGMENTS

The Author would like to thank Universal Studios, the world's dream factory for over 100 years.

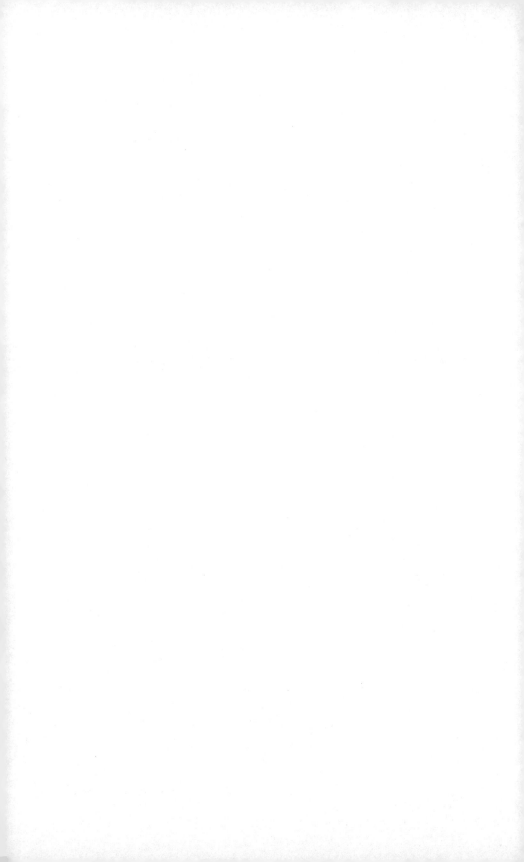

Good evening, ladies and gentlemen, and welcome to *Psychos...*

My name is not Alfred Hitchcock. I am here however to tell you a story of woe, disgust and murder and I'm not referring to the box office returns of the remake!

I'm here tonight to weave a complicated tale, starting with the sickening murders of a real life maniacal murderer through to the Master of Suspense and beyond to today's television. I am of course referring to the *Psycho* franchise. A complicated history of passion, perversion and pictures; a notorious murderer, a genre defining movie and a back catalogue of endeavor that lasts to this very day.

In total the franchise includes: 4 novels, 3 major motion pictures, 1 remake, 2 TV movies, 5 seasons of a TV series, 1 former theme park attraction, scores of documentaries and now this book detailing the history of surely the world's greatest psychological-thriller-horror franchise.

Ed Gein

Why do people kill? No offense can be compared to depriving another human of the right to live. Thousands are killed on a daily basis all over the world. It ranges from child killing to genocide. Irrespective of cultural, religious, and legal prohibitions, people still kill. Most theories have failed to explain why people kill. Most theories cannot explain the high rate of homicide among tribal cultures with the lack of media access. Some other theories invoke modern causes but still cannot explain the records of skeletons and skulls that contain tips of arrows, stones, and other brutally inflicted fractures.

Many homicidal people have served as inspiration for the creation of many books, movies, TV shows, and even other homicides. The only thing that can stand in comparison with murder regarding savagery is body snatching for aesthetic purposes. Imagine a human being deriving pleasure from cutting out the organs of a dead person bits by bits and adding them to a collection of similar parts. Making masks and body suits from the body of the dead as though they are unique antiques.

So, what happens when a person is not just a murderer but also a body snatcher? What tag can be awarded to such a person? If you had the power to look into the mind of a

body-snatching murderer, would you? Will you want to learn why? Will you find yourself shivering in fear as you step into the mind of someone so deranged?

Many of these deviants have lived in this world but none has had as much impact on society like America's most dreaded murderer and body snatcher Edward Theodore Gein. Ed Gein as he was popularly called was a body snatcher and murderer in the American society for so many years. His crimes, which were committed within his hometown and beyond served as an inspiration to many books. Why so? What crimes did he commit and why has his name continued to ring in history till this day? Was it about the crimes or was it the way he planned and accomplished them? What exactly were his motives? Why did Ed Gein kill and what was so unique about his crimes that inspired the creation of the award-winning novel *Psycho* by Robert Bloch?

The answers to these questions and more will be revealed within the pages of this book. Hopefully, you would come to understand the mind of the body snatcher and murderer Ed Gein and why his life inspired Robert Bloch to write the novel *Psycho*.

So come with me and together we will explore the mind of the psycho who has inspired so many…

The Life of Edward Theodore: The Stimulus

Born on August the 27th, 1906, Ed Gein was a murderer and body snatcher whose crimes instilled fear in the hearts of the every American alive in the 1950's through 60's. Apart from the murders he committed, Ed Gein had a habit of exhuming bodies and making some parts, mainly the skin and bones, trophies in his collection.

What was his background? Where was, he born? What circumstances led a sweet young boy grow into an

unrecognizable monster?

Ed Gein was born to Augusta Wilhelmine and George Philip in La Crosse County, United States. He had a brother called Henry Gein. His mother Augusta hated her husband who was an alcoholic that could not hold down a job. Due to his inconsistency, Philip worked as a salesperson, a carpenter, and Tanner at different times in his life. At one point, he owned a grocery shop with his wife but eventually sold the business out. After that, the family moved from the city to Plainfield which then became their permanent residence.

Augusta took full advantage of the settlement. She shielded her sons from outsiders with the intention of keeping them safe from negative influences. Ed Gein only left the house when it was time to go to school. When he wasn't in school, he spent hours working on the farm. He didn't associate much with others and was classified as a shy kid.

"He was a quiet kid and kept himself to himself. He didn't mix and he didn't hang on the street corners like the other kids. To the outside world he was just a harmless kid with a lack of sociable skills."

An unnamed resident recalls.

Being a Lutheran, his mother emphasized on the innate immorality of the world whenever she preached to her sons. She always condemned drinking as an evil and thought her children that women are natural instruments of evil and are all prostitutes. Every afternoon, Augusta made out time to read and meditate on the Bible. She also read the Bible to her boys and was specific about portions of the old testament which emphasized murder, divine retribution, and death; little did she know that she was breeding a monster in her own home.

His classmates and teachers acknowledged that Edward was a shy kid. His mannerism was strange; this minute he laughed and the next minute you'll find him frowning. Most times he made jokes and laughed loudly at his jokes even when no one else was laughing. What's more? His mother punished him critically anytime he made any efforts to make friends. Irrespective of his poor development socially, he did well in school and especially loved reading.

Edward's father George died at age 66 as a result of heart failure inflicted on him by his alcoholism in 1940. Following his death, Henry and Edward got jobs within the town to help sustain the family. They were honest, reliable and hard working, to say the least. Despite the fact that both worked every day as handymen, Edward enjoyed babysitting for his neighbors from time to time. He was indeed a loving young man with a good heart or so the town thought. It was not difficult for him to relate to children compared to adults.

Eventually, his brother started dating a single mother and made plans to move in with her. Henry was often worried about how much Ed loved his mother and spoke ill of her several times, living Ed in emotional pain and shock.

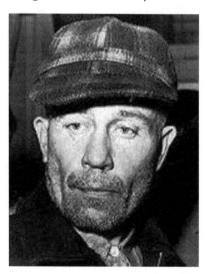

So what happened to this sweet young loving boy named Edward? In 1944, sometime in May, Edward and Henry attracted the attention of the fire department while burning marsh vegetables on their family property. The fire went out of their control and took the firefighters hours to put out. Afterward, Edward noticed his brother was missing and sounded an alarm. Diligently with flashlights and lanterns, a search party moved out to find Henry. After a rigorous search, Henry was found lying dead with his face on the ground. The crowd concluded that the young man died of heart failure just like his father as he was not hurt by the fire and did not sustain any visible external injuries. However, in the biography of Gein, Harold Schechter reported that the young man had some bruises on his head on the day he died. A coroner revealed that the young man died of asphyxiation. Although the police accepted the alleged accident theory, there is no official proof of an autopsy.

There are those who believe that Ed Gein killed Henry, but there is no evidence of that. During the investigation of another murder in 1957, a state investigator called Joe Wilimovsky brought up a question concerning the death of Henry and the psychologist in charge of the case believed that Henry and Edward were more or less Cain and Abel; Edward was Cain.

Following the death of Henry, Edward lived alone with his mother who was paralyzed after a stroke. Reports revealed that Edward devoted time and energy caring for her day and night. In the year 1945, Edward said that his mother and himself went to a man called Smith to buy straws. According to him, he and his mother found Smith hitting a dog. A woman (probably his lover) screamed at Smith to stop while the dog was still alive, but he didn't stop until he beat the life out of the dog. His mother was upset after the scene not because of the brutality but because of the woman she found in his house. She told her son that the woman was not married to Smith and so she was not meant to be in his

9

house. A man had just beaten an innocent animal to death, and the only thing she could think about was immorality. She referred to the woman as "Smith's Harlot." Augusta's health deteriorated rapidly, and she suffered a stroke after some time. On December 29, 1945, she died at age 67. Edward was left bitter and depressed after Augusta died. At this point, Edward was alone in this world as he had lost his one true love and his only friend.

> "The world was said to have more or less died for Ed the moment his mother left this mortal coil."

An unnamed resident recalls.

Her death was not the beginning, but only a stimulus that triggered the monster inside, like the phoenix from the ashes Ed's life was gone and now only the monster remained.

The Crimes of Ed Gein

It all began in 1957 on 16th of November when Bernice Worden disappeared. Worden was the owner of Plainfield hardware store. According to her son, Gein was the last person to see Bernice alive that evening. He claimed that Gein discussed a business transaction with his mom and promised to return with a gallon of antifreeze the following morning. At this point, Edward was already a suspect in the case. The last receipt the lady wrote was for him on the morning of her disappearance.

The police got a warrant to search Gein's property for evidence and were shocked when they found the decomposing body of Worden in a shed. She was hung upside down with ropes on her wrists and a crossbar on her ankles. Her torso was dressed like a deer, and she was shot with a rifle ascertained to be .22-caliber. The mutilations were performed after she died.

As they searched his house, they found a lot of gruesome

things including;

- A wastebasket made completely out of human skin.

- Bones and fragments of bones.

- Skulls were placed on his bedposts.

- Some of the female skills had sawn off tops.

- He had a corset made from a woman's torso and skinned from her shoulders to her waist.

- Human skulls were carved into bowls.

- The female skin was used to make masks.

- Leggings that were created from human skin particularly from the leg.

- The face of Mary Morgan was found in a paper bag along with her skull.

- The entire head of Bernice Worden found in a sack.

- The vulvas of two fifteen-year-old girls along with a young lady's dress found in the bag.

- A belt ensure made out of female nipples.

- The heart of Worden found in a plastic bag.

- A pair of human lips.

- A lampshade that was made from human skin.

- Four human noses.

- Female fingers and fingernails.

These gruesome artifacts were destroyed after photographs

were taken.

During interrogation, Gein told his investigators that he made forty eight different visits to about three graveyards to gather freshly buried human bodies which he decapitated and made part of his collection. According to his statement, he was in a daze-like state when he made these visits between 1947 and 1952. Ed reported that he woke up from the gaze sometimes and walked out of the cemetery without carrying any dead body. When he was on the gaze, however, he exhumed bodies of typically middle-aged women whom he felt had some resemblance to his mother and took these bodies home. At home, Edward tanned the skin of his victims to achieve a particular effect he was interested in.

He also admitted to exhuming nine graves, and freely led the investigators to each location. Due to uncertainty concerning whether Gein was physically capable of singlehandedly committing the crimes, they had to exhume two graves. To their surprise, both were empty. This corroborated his confession. All the graves were exactly as described; not one was different.

He's obsession for body parts started after his mother died. Gein wanted to create a body suit for himself so as to literally crawl under his mother's skin. He wanted to become his mother; this was his response to grieving propelled by the stimulus of her death. Psychologists described the reason behind the tanning and donning of victim's skin as a transvestite ritual. He claimed that he had no sexual relations with these dead bodies because he could not endure their smell. He admitted to shooting one of the victims whose head was found in his home; Mary Hogan. Hogan was a tavern owner who mysteriously disappeared in the year 1954. However, Gein eventually denied having any memory of the events that led to her death.

Before the case, a 16-year-old boy reported that Gein kept contracted heads in the house, but no one believed him. Gein later related that these heads were relics from the Philippines which he received from his cousin. Gein claimed his cousin served on the island during World War II. The police also discovered that these parts were carefully peeled off facial skin from corpses which he converted and used as masks. Gein was also the suspect in so many other unsolved cases within his town including the disappearance of Evenly Hartley.

The County Sheriff named Art Schley is said to have assaulted Edward while he was questioning him. He banged his head into the wall in anger because he lost control after Gein confessed to his crimes and after what he saw. The assault rendered the first confession Gein made unacceptable. In the year 1968, Schley died as a result of heart failure before he had the opportunity to witness the trial and testify. Personal friends of Schley claimed that the horror of Gein's crimes wee too traumatizing for him to handle. He couldn't stand the idea of testifying, especially concerning the assault. This may have lead to heart failure which killed him.

> *"Schley was another victim of Gein in a way. He witnessed the entirety of what he did. He didn't need to beat a confession out of him, he just lost his temper at what he saw and the manner of the man."*

An unnamed resident recalls.

The Trial of Ed Gein

On the 21st of November in the year 1957, Ed Gein was arraigned. He was charged with one count first-degree murder in the Court of Waushara County. He pleaded guilty but because of insanity. After critical examination, had been carried out, he was found mentally incompetent and unfit

for a trial. Subsequently, Ed Gein was remanded in a central state hospital particularly for the criminally insane. This facility is presently known as the Dodge Correctional Institution. Eventually, Gein was transferred to Mendota State Hospital Wisconsin. During his stay in this institute, the doctors discovered that he was living with schizophrenia.

Doctors later found that Gein was capable of conferring with counsel so he could participate in the defense. In 1968, a trial commenced, and a psychiatrist was made to testify on his behalf based on what Gein had disclosed to him during treatment. According to the psychiatrist, Gein confessed that he wasn't sure if he killed Worden by accident or deliberately. Gein told the psychiatrist that he accidentally shot Worden while examining the gun. On his part, he testified that while he was testing the weapon, it went off and killed the lady even though he was not aiming at her. He also said he didn't have any memory of what happened after that.

Although Edward was found guilty by Judge Robert H. Glomar on November 14th, he was found not guilty after his second trial because of insanity. He was, therefore, remanded in a mental facility where he lived out his days. Despite the fact that he confessed to killing Mary Hogan, he was tried solely for the murder of Bernice Worden.

Following his trail and arrest, his property and home were auctioned out on March 30th, 1958, and his home was rumored to have become a tourist attraction; after which a fire destroyed his farm. The authorities suspected Arson, but there is no official record of what really happened. When in detention, he learned of the incident and said, "just as well."

His car which he used to transport bodies from the cemetery to his house, was auctioned out for $760 to the operator of a carnival sideshow called Bunny Gibbons. Carnival goers

were charged 25¢ to see the car; the car of the body snatcher Edward Theodore Gein. For an extra quarter you could sit in it too!

Crime Case: Start to Finish

The previous chapter was more or less a summary of the crimes of Ed Gein. This chapter, however, is a walk through on every single detail surrounding the crimes of Ed Gein, those of weak constitution should probably read on...

Ed Gein was a shy young boy and even when he crossed puberty, he was still a quiet young man who didn't mingle much. Ed was the kind of man no one suspected. He didn't look like a deviant and nothing in his social life sold him out, at least not to the naked eye. It was only during his trial that speculations were raised concerning the possibility that Edward was responsible for his brother's death. This led investigators to believe that Ed Gein's problem started when he was much younger. However, the case, the real crime case began on the 17th of November 1957.

After 58 years, old Bernice Worden disappeared, her son pointed his fingers at Ed Gein and the evidence available in her store, missing the money, and a blood trail towards his farm showed that Gein was the last person who saw Mrs. Worden alive. The authorities started an investigation at once and Arthur Schlep (sheriff at the time) went to search the apartment of their number one suspect, Ed Gein. On arriving the farmhouse in the evening, Schley was shocked at what he saw as he had never seen anything as gruesome in all his years of service. A nasty surprise it was indeed.

At this time, Ed Gein was 51 years old. He was not on the farm when the sheriff arrived, but the sheriff searched the premises because he had a warrant. As Schley tread through the trash in Gein's dark kitchen, he stumbled upon something hanging from the ceiling. He pointed his touch

towards that direction, and to his ultimate surprise, it was a human body. The body he saw was disemboweled, naked, beheaded and hung upside down. Blood rushed through his veins with so much speed, and his skin was filled with goosebumps. In his mind, Schley thought "what sort of human could be responsible for this"?

The carcass was no other than the freshly gutted remains of Mrs. Worden. The cavalry secured the farmhouse and performed a rigorous search on the premises. They found the head of Mrs. Worden in another part of the house. On the body of the dead woman were nails hammered through her ears locked in with a twine. It looked as though he was preparing her head to be hung up as one of his trophies.

The detectives in charge spent that entire night to the following morning sweeping the premises. The things they saw; all the things they found in Ed Gein's home they could never forget. Their findings marked a terrible new low in the Archives of American crime.

A human being, a man, had been using female's parts to make a series of mysterious artifacts. "Who in this world makes a belt out of female nipples?" they thought. Ed Gein took his precious time and used a human skull to make a soup bowl and lampshades. His home was full of chairs dressed with human skin. He collected a box of human noses; a curtain was made with human lips sewed into the box.

As the search went on, they found a shoebox kept safely beneath a bed and inside it was the genitalia of a woman. Inside the closet, there was a shirt made out of the human skin with the breast still in tact. On the wall of the interior part of his building hung human faces cut clear from their bodies. Nine female faces peeled from their heads. They were persevered properly in his bizarre collection. At this point, Ed Gein had some explaining to do.

The Arrest and the Confession

As soon as the police spotted the body snatcher, they grabbed him and arrested him taking him at once to the Wautoma Jailhouse. When they got there, the interrogation began and although Edward denied everything at first, he eventually cracked and made a confession.

Ed Gein admitted to killing the storekeeper Mrs. Worden after hours of questioning. He shot her in the head with a gun from her own store. It was a .22 caliber rifle. After he had killed her, he pulled her lifeless body to his car leaving a trail of blood on the floor while transporting her body to his vehicle. With his car, he drove her back to his farmhouse where he slowly decapitated her bit by bit until he was satisfied. Everyone was shocked at his confession. They all wondered what form of evil would have propelled such an action.

After giving the details of Worden's murder, he confessed to the murder of a woman (another storekeeper) named Mary Hogan. Mary Hogan mysteriously disappeared three years before the murder of Bernice Worden. Ed only admitted to two murders claiming that most of the body parts were gotten from human bodies he exhumed from the cemetery on various occasions. He confessed that he went with a friend to the town cemetery to dig out freshly buried bodies with incomplete graves. The interrogating officers were not completely sure Edward was telling the truth as they suspected him for four previous murders dating all the way back to 1947.

The murders included an eight-year-old called Georgia Weckler who disappeared mysteriously on her way back from school, a 15-year-old known as Evelyn Hartley who was kidnapped while she was on babysitting duty. Other suspected victims included Ray Burgess and Victor Travis who also disappeared without a trace in 1952. Gein denied

killing these people and their body parts were not found in his home. There were no male parts in his home either. His obsession was reserved strictly for females.

The funny thing about Gein was that he never carried the full bodies. He only took the parts he needed for his collection and left the remains in the grave. In the context of the case, the police had to dig open the graves of eight women. When they did, they found that every last one was mutilated. Parts like their faces, skin, breasts, genitalia and other body parts were missing. He took the bodies out, removed the necessary part and returned the body carefully back to the coffin. After that, he replaced the dirt to avoid suspicion.

There are those who believe that Gein didn't just start killing. He was more interested in the body snatching aspect. He engaged in several night-time raids with one of his trusted friends identified as Gus. Unfortunately, Gus was sent to an old people's home, and Gein was left with no choice but to start killing to satisfy his innate needs.

Note that these raids were not blind raids. Edward had details of these women. He read their obituaries from the newspaper and went for their bodies the night. During his integration, Gein casually told the officers that he usually wore human skin shirts around his home during the dark hours of the evening. He placed the genital areas of the women over his naked groin to play the part of a woman. He assumed the role of his mother. For a certainty, Gein was a virgin, but somehow, he was freakishly obsessed with the sexual power of women. The officers, the court, and entire town were left with one thought; why? How Did Edward Gein Become a Psycho?

Understanding the Mind of Ed Gein

Edward Gein, like every other baby, was born with his mind

as a blank slate; *tabula rasa*. He was an innocent joy bundle with no knowledge of right or wrong, hate or love, moral or immoral. In the state of Tabula Rasa, the child has no inbuilt mental content and every knowledge is gotten from day of birth to the day of death through experience and perception. That is to say; there is no knowledge in the mind of a newborn. The child is nurtured into the society. The social, emotional and psychological components of an individual are developed through learning and experience. This child develops these traits through socialization.

The socialization a child receives from birth will have a lasting effect on the ability of that child to interact with other members of the society. Edward's problem started and ended with socialization. The socialization he received as a child was mostly from the primary agent; the family.

Almost every behavior he exhibited, even those considered to be natural were developed through socialization. It was during his socialization with his family that Ed slowly developed his twisted personality traits. The norms and values he learned as a child were biased and only gotten from his mother. He had little or no opportunity to learn from external sources. His mother was a fanatic who had a strange and irregular view of the world. Since the primary agent of socialization is the family, and Ed Gein had just his mother and brother to the learn from, it's safe to say that his life was significantly shaped and almost entirely influenced by his mother.

Augusta had a dominant personality and a rather annoying puritanical view of the world and life itself which was based on radical Christianity. She was practically the dominant head of the family and day and night she taught her children about the inherent immorality of this world. She also regularly condemned the evil twin; alcohol and women with no restraint. She kept emphasizing on the sins of carnal desire and lust all the while depicting all women (herself

19

excluded) as whores.

Ed Gein And Sexual Confusion

Due to her strict lifestyle and unrealistic expectations of her sons, Ed began to buttress feelings of sexual confusion. He had a natural attraction toward girls like every young man would, but this attraction clashed with his mother's constant warnings. Since he was a naturally effeminate and shy boy, he never had the courage or opportunity to date any girl. He had no real or healthy attraction to girls. He hardly had any interaction with females and had a seemingly oedipal devotion to the mother. Augusta was strong. She was a domestic rule maker, the breadwinner, an unfortunate wife, and mother.

She was in charge of a grocery store when her children were younger, but she got tired of the depravity of the city and moved her family over to a farm which was 195-acres large. There she lived with her family in serenity for over 25 years or at least that was what she thought. After the death of her irresponsible drunk of a husband in 1940, she continued to live with Henry and Edward in the farmhouse. Although their lives were far from regular, Henry longed for a normal life like every young man would. He looked forward to life with a family of his someday. Frequently, he bad-mouthed his mother in the presence of Ed. However, despite the efforts Henry made to change Edward's views, Ed remained a devoted servant of his mother.

After Henry, had died, Edward and his mother lived alone in the farmhouse. Even with her poor health, she still gave Ed a lot of trouble. She had annoying mood swings and harshly reprimanded her only living son. She raised her voice at him and accused him of being as irresponsible as his father. However, when she was not condemning Ed, she was speaking to him softly encourage him, and she even allowed him to sleep in her bed right to her.

It didn't matter if Augusta was a pain in his neck; Ed loved her and devoted his life to her. To him, she was a goddess who knew everything. As a result of his strong attachment to her, he was broken and completely deranged after she lost the battle against cancer on the 29th of December 1945. He deserted almost every room in his home especially those he closely associated with his mother. He confined himself to the kitchen and one tiny utility room. He filled these rooms with anatomy books and pulp fiction. He majored on stories about South Sea cannibals and wartime atrocities. All this time he trained himself for body snatching. He went even further to prowl the cemetery for what can be referred to as a nasty experiment of his learned skills. As soon as he got the information about the funerals of these women he prepared his tools and went to harvest the parts in the dead of night. He preferred older women perhaps because he wanted people who reminded him of his mother.

Ed took out time to cut the whole breast, genitalia, skin, and nose of the women fashioning them into trophies and placing them in his home. Ed rarely had any visitors, but the few who visited the farm claimed to have seen a glimpse of his ornaments but never really believed what they saw or got the real picture. Edward didn't care that he could get caught, he kept busy with his handyman jobs during the day and body snatcher during the night.

For years, no one noticed his grave-robbing antics. It wasn't until 1954 that he had no choice but to give up on his grave-robbing since he didn't have anyone to assist him anymore. This was his only reason to kill. He had to get the body parts somehow.

What Went on in His Brain?

There are basically three theories to explain why an individual could opt for body snatching and killing. Some people believe that a person must be affected in one out of

the three dimensions namely; spiritual, psychological and physical. Those who research into the spiritual dimension claim that the cause of something like killing must be spiritual. On the other hand, those who study psychology believe that the fundamental cause of murder and body snatching lies in the psychological dimension.

In the case of Ed Gein, his brain was responsible. His problem was purely psychological, and this is why he was declared mentally unfit by the court. In a nutshell, his mother was responsible for making him obsessed with human flesh. Her attitude and lessons twisted Ed's mind so much. She was his single source of joy and pain. Her death left him alone and devastated and so his need to satisfy that void left by his mother manifested into an unhealthy and unnatural fixation.

Edward's case was not ordinary. He wasn't a normal person. However, as the law would have it, his sanity was in question, and everyone had to be sure beyond reasonable doubt that Ed was insane. When his hearing began, his not guilty plea was based on insanity. He was subjected to a series of psychological tests. All the tests carried out proved that Ed Gein was indeed emotionally impaired. He was diagnosed with schizophrenia and was a sexual psychopath.

Their conclusion was that his mother was responsible for insanity. She could also be considered as an unstable woman herself. If not, why would she isolate herself and her children from the world and build such an unhealthy codependent relationship with her son? Her upbringing led an innocent child to grow up with conflicting feelings about all women. While the man in him naturally wanted to have a relationship with women, the part of his mind that dominated by his mother conflicted with his natural thoughts. What Augusta thought him was unnatural and unhealthy. All his life he had a love-hate feeling towards females but the death of his mother triggered his brain into

22

full-blown psychosis.

This was the report presented by Dr. Schubert who was in charge of examining Ed Gein in the Central State Hospital concerning Ed Gein's mental state;

> "The death of his mother (Augusta Gein) left him feeling empty and devastated arousing within him the need to arouse the dead through will power. He strongly believed that with strong enough will, he would successfully raise his mother from the dead. However, when he failed in his quest, he was disappointed. He began to exhume bodies of women he believed looked like his mother with the same aim. Again, he failed. He resorted to making human suits which he would wear and play the role of his mother. All the evidence gathered, and the examinations carried out proof that Ed Gein took to body snatching as a response to the demands of his abnormally magnified fantasy life fueled by his attachment to his mother".

Concerning the human suites found in his home, another experienced psychologist commented;

> "Edward Gein made human suits following the loss of his mother because he wanted a substitute for his dead mother that would last for eternity. This way he would never lose his mother again. "

Many people believe that Gein engaged in sexual activities with these corpses and was also a cannibal. However, he denied ever having any sexual relations with any body part or a full body. His final psychiatric report revealed sexual fixation. In the same light, he denied being a cannibal but people knew him to distribute "venison"- he, however, claimed that he never hunted a deer.

Whatever the details of his life were, one thing was certain;

his psychosis was evident. First of all, his childhood and his entire life for that matter was of extreme isolation. Apart from going to school, he was not exposed to the outside world in any way. He had no real-world experiences, and his extremely religious mother influenced his morals and values. He was never allowed or even capable of making friends and spent his life with his family.

During a time when he was employed as a handyman and a babysitter, no one ever suspected him of being mentally unfit. People within the town saw his as a hardworking man who was strange and had an awkward sense of humor, but they never imagined that he was a Psycho. The community was absolutely stunned after his conviction. Who would have ever imagined that a quiet and hard working person like Ed was capable of such inhuman and insane things? It didn't matter if Gein was eccentric, he was a member of their community; the town's oddball.

Those in the spiritual camp doubt that Gein had any psychological problems and claimed that he was controlled by the spiritual; Ghosts and the likes. Was this true? Some others claim that Gein had powerful biological disorders. However, various neurological studies were carried out, and there was no evidence of any hereditary disease that could have led rich such behavior. There is no legitimate way to know what role neurotransmitters played in his actions. There were no biological studies done to determine the role of his neuroanatomy in his actions. Only the psychological conclusions were tested and proven.

From a psychological point of view, a person living with schizophrenia is expected to be delusional, suffer from visual or auditory hallucinations, strange behavior, and inappropriate thoughts and actions. For a certainty, Gein was not well. He displayed core symptoms of schizophrenia throughout his life. The fact that he strongly believed that willpower was enough to bring back the dead or make him

transform into a woman was enough evidence to show that he was indeed delusional. During interrogation, he never described any situation that had semblance with hallucinations. For example, Gein never claimed his dead mother was controlling him or asking him to do certain things from the grave. What she taught him influenced his mind after her death. Gein was also capable of taking full care of himself and maintaining the farm. He didn't speak in a chaotic way or act that way either. Irrespective of the fact that he was the oddball, and acted weird at times, his actions were not as inappropriate as most mentally impaired people were. This is why some people did not support the claim that Gein was indeed living with schizophrenia. They agreed that he exhibited some of the aspects of the disorder, he did not completely meet the criteria.

Was Ed Gein a Sexual Psychopath?

A sexual psychopath is an individual whose main motivation is the urge to gain a form of sexual relief. Any crime such a person commits is channeled towards gaining sexual release. This means that the person gains sexual stimulation through actions. So, could Gein be tagged as a sexual Psycho?

Although Edward was accused of subjecting the corpses to sexual acts, he angrily denied these accusations insisting that the bodies stunk too much. He's reason for exhuming corpses was primarily to make items in his home. He wanted to know what being a woman was like so he tore off pieces of the body parts and wore them at night. As abnormal and crazy as the situation was, it still doesn't dismiss the fact that these activities were sexual in nature. Gein did not confess to any sexual stimulation in all his reports. He also did not report any evidence of sexual activities in all his interviews.

In this light, it will not be completely accurate to refer to

Gein as a sexual psychopath. His personality was a simple person who confessed to all his crimes, so he had nothing to lose by telling the truth. There was no reason for denying that he had sexual encounters with those corpses if he really did. In addition, he displayed little resistance after he was caught and was extremely cooperative. He confessed to his crimes and took the officers to his grave when he was asked to. People who are sexual psychopaths always have elements of shame when it comes to the commission of crimes. It is always their intention to hide their motives. If they don't have elements of shame, they will have elements of pride and arrogance. They always prefer to conceal part of their crimes even after they have been caught. You find such persons holding these crimes over people. Gein was a helpful and open minded person, and he was not prone lying. In all cases, he displayed a lack of sympathy or remorse; it's possible that he didn't know better.

From the sociological point of view, he didn't know much about socializing. He lacked that sense of social life and solidarity. The location of his home led to isolation for the rest of the town. He had no friends, exposure or any communal experience. This made all narrow-minded teachings of Augusta create a socially disorganized lifestyle for her son. Gein had no motivation model except his mother to build him up. He subsequently had a socially stunted growth and lacked any appropriate moral structure.

Considering the way, he acted after he was caught and during the first trial, it is safe to say that Gein had no idea what the gravity of his actions was. He was not aware of the social taboos he committed, and he had little or no memory about the two murders. He didn't follow his mother's preaching regarding women despite the fact that he loved her and was loyal to her. Still, these teachings shaped him in thoughts and actions.

According to this camp, Gein is neither schizophrenia nor

was he a sexual psychopath. So, what was he? He displayed significant symptoms of delusional disorder throughout his entire adult life. Although he opened up after he was caught, he lived a very secretive life before then. He didn't let people visit him and made little efforts to visit others. He only used these bodysuits at night, and this proves that he was aware that his actions were inappropriate. He enjoyed and practiced these delusions despite the fact they were all against his biblical upbringing. All these things were against Christianity, but Gein did them anyway. The nature of his crimes and his criminal impulses show that he invested in his delusions psychologically. The way he achieved his delusion was indeed horrific. His fabrication of the human suit was extreme in comparison to wearing female clothes, shoes, and the rest. What he did was strange, but it is still classified as a delusional disorder.

The Media's Perception of Gein

During the time of the case and long after that, the media portrayed Gein as no more than a horrific sexual psychopath who drew excessive conclusions from his actions and upbringing and becoming the most monstrous villain ever known. However, what he did was as a result of a twisted perfect windstorm of nurturing, a social isolation and a psychological disorder. All his crimes became a sensationalized villainization of someone who had no traditional motives of fictitious offenders. It is true his crimes were horrific, but his personality doesn't portray him as the Plainfield Butcher.

During further interrogation, and psychological analysis, the investigators, continued to see achievements the town thoroughly. Despite the fact that they discovered that Ed really got bodies from the Cemetery and only killed two women, they had reason to suspect that he may have killed a third person. This is because skeletal remains not belonging to any of the nine corpses were found in his

home. This led them to believe that Ed may have had a third victim. The skeleton belonged to Travis Victor who went missing years before the case. As soon as the officers found it, they took the remains to a lab for a full examination.

Ed did not show remorse or even any emotion at all when he was being interrogated. He talked about all he did as though he was talking about a visit to a friend's home to pick out some fruits or a visit to the mall. Ed had no concept of the monstrousness of his crimes.

What Makes an Ed Gein?

People often wonder, how can a child become an Ed Gein? What should I look out for? How do I know when my child is nursing psychopathic ideas?

There are a few characteristics that are common among psychopaths. Parents or guardians must be extremely cautious with the type of information they feed their children. This is because people are not always born psychos if they ever are. Those who influence their lives the most are often responsible for their mental problems. In the case of Gein, his mother was the problem. Perhaps if Augusta had the slightest idea that her son will become a body snatching murderer because of her influence, she would have done a better job.

Not everyone with bad and unhealthy upbringing becomes a psychopath. However, there are three groups of people who most likely start killing.

The first group is made up of those who are delusional insane just like Gein. The second set involves individuals who are suicidal depressed. In some occasions, however, an individual can have these two substances. This is more likely as result of a brain tumor and not just upbringing or social life.

Psychopathy is simply a personality disorder, but you cannot always identify a Psycho by the way they talk or act. Psychosis can also be spotted with less obvious reasons especially when the individual is good at hiding.

As it would appear, those who are born or who grow up into psychopaths do not have the ability to display or even feel empathy toward others. They disregard the feelings of other humans and can commit the most heinous of crimes and tell lies perfectly without getting good caught. In most cases, a psychopath has no idea that a law is being broken either against nature or against the state because they lack that ability to feel bad or feel guilty.

Just like Gein, most psychos have been taught over and over again about how wrong something is. They have a consistent reminder of bad and evil. Thus, they have to remind themselves that it is bad or wrong because they can repeat the action several times with no feelings of remorse or guilt.

No matter what the circumstances are, they never feel or care about individuals or animals. Some start torturing animals from childhood. The sadistic psychopaths enjoy thinking about or carrying out the torture of living things.

An example of such a psychopath is Eric Harris, a Colombian shooter. He was also a sociopath. At one time, he boldly declared that all humans are disposable just like fungus in a dish. He had a journal which he filled with remarks about how he wanted to kill everyone in the world. He wanted everyone dead because he hated everyone. Harris was different from most psychopaths who conceal their hate and disregard for others. Most psychopaths with high IQ's end up being criminal masterminds, successful business people, and legendary politicians. In most cases, it's those with low IQ end up in jail.

General Characteristics of Psychopaths

To identify a psychopath, here are their general characteristics, for which you can see how many telltale signs Gein had displayed;

- Pathological lying- psychopaths lie constantly to hide their psychopathic traits.
- Lack of remorse- they do not feel regret after committing vicious crimes such as murder.
- Shallow emotions- they are incapable of forming emotional attachments and if they do feel any emotions at all it is usually short-lived.
- Lack of empathy- psychopaths are usually insensitive and unsympathetic which explains why they disregard the feelings of others.
- Refusal to accept responsibility for their actions- they blame others for their own wrongdoing and fail to admit their fault.
- Grandiose self-worth and self-centeredness- they exaggerate their worth and abilities and are driven by reward and the benefit they derive from doing anything for others.
- Parasitic lifestyle- they intentionally use and live off others for selfish reasons.
- Deceptive and manipulative behavior- psychopaths are cunning and often use deceit to cheat and defraud others.
- Glib and superficial charm- often they tend to be smooth, engaging, charming. They mimic emotions to appear normal to others and gain their trust.
- Juvenile delinquency-they often disregard the law, breaking set rules and curfews even when they are aware of the consequences.
- Poor behavioral controls- psychopaths are impulsive and act hastily. Keeping behaviors such as anger and aggression in check is often difficult.

- Cold and unaffected by threats of punishment- even when psychopaths know the consequences of their actions they are unmoved.
- Engage in reckless and dangerous activities- they are fearless and carry out activities that can hurt them and others such as setting fire, torturing and killing of animals and reckless driving.
- Crime versatility- they engage in various criminal activities such as stealing, property damage, breaking of probation rules and generally violating the rights of others.
- Promiscuous sexual behavior- psychopaths are often involved in indiscriminate sexual activities and numerous affairs at the same time.
- Need for stimulation and tendency to boredom- psychopaths have an excessive need for exciting stimulation and are easily bored. As a result, they find it difficult to complete a task they consider routine or dull.
- Failure to set realistic long-term goals- they live a life lacking direction and fail to develop and work towards the achievement of long-term goals.
- Irresponsibility- psychopaths do not attach any importance to honoring of obligations and commitments.
- Early behavior problems- from an early age usually before their teenage years, psychopaths begin to exhibit criminal or antisocial traits such as theft, bullying, use of alcohol, vandalism, and the likes.

The fact is, from an empathic point of view, Gein was not a real psychopath. His condition was pitiable and he needed help. Painting as a villain will be unjust but so is this world. It would be this portrayal through the various forms of media that he is most remembered today; no less in his inspiration of this film series.

the Book

According to Bloch's most recent biography written in 1993, the story *Psycho* is based on what happened to Ed Gein. He wrote the novel with the major character, Norman Bates taking the fictional role of Ed Gein. Many people will be familiar with the movie of the same name, but in the book the character is wildly different from the on screen portrayal. It is by far a more direct portrayal of Gein.

In the 1959 Edition, Clive Barker noted that the story is much more scary in the novel than it is in reality, but was it? Can anything compare to the real life story of Ed Gein? To date, *Psycho* provides one of the most incredible reading experiences in the horror genre. The book ignites a mood that surpasses the simple bleakness of typical horror novels. Perhaps this is because it was based on a true-life crime that was still fresh in the minds of the readers. Not just any story but the story of America's most twisted villain Ed Gein.

Robert Bloch was inspired by the story of Ed Gein irrespective of how sick it seemed. He started writing with inspiration and fire in his heart until he finished creating the book *Psycho*. The novel was a unique source of entertainment. Reading the novel moved people to learn more about the life of Ed Gein. The major character in the story was Norman Bates who played the role of Ed Gein.

"She'd come back here, then; come back, changed her clothes, and gone off once more. He couldn't call the police. That was the thing he had to remember. He mustn't call the police. Not even now, knowing what she had done. Because she wasn't really responsible. She was sick. Cold-blooded murder is one thing, but sickness is another. You aren't really a murderer when you're sick in the head. Anybody knows that. Only sometimes the courts didn't agree. He'd read of cases. Even if they did recognize what was wrong with her, they'd still put her away. Not in a rest home, but in one of those awful holes. A state hospital."

Robert Bloch, Psycho

Norma is for sure a lifeless body. She's a distant memory and has been since she allegedly committed suicide after killing her significant other or at least that was what everyone believed. In any case, Norman's side interests, especially his love for taxidermy, moved him to settle on a grim choice. Before the anguish of a mental break down inflicted after his mom's passing that led to his admission to a psychiatric home, Norman dug out his dead mother from the earth and kept her body in her home where he lived.

The man did everything possible to continuously physically preserve her, and he's found a degree or measure of comfort in Norma's presence. That same comfort, in the long run, gives finish life to the two extra identities (small Norman and Norma) will meet in the early phases of the story. It might be said; Norman makes himself crazy.

He and his mother had regularly kept up a weird relationship. His mom was not just a lady who controlled others; she totally suffocated the young man. An abnormal, unhealthy association between the two is suggested in the story. However, Bloch never hits readers with cold hard

truths concerning if the two were intimate in any capacity. We'll never know without uncertainty. However, Bloch unquestionably lays a sufficient establishment of that conclusion.

The big question; why bring that same cold hearted lady that is kept you down your whole life right back into your life after you killed her? Evidently, Norman was bound to carry on with the life of a crazy person, unequipped for familiarizing himself with anything remotely close to regular.

> *"Then she did see it there - just a face, peering through the curtains, hanging in midair like a mask. A head-scarf concealed the hair and the glassy eyes stared inhumanly, but it wasn't a mask, it couldn't be. The skin had been powdered dead-white and two hectic spots of rouge centered on the cheekbones. It wasn't a mask. It was the face of a crazy old woman. Mary started to scream, and then the curtains parted further and a hand appeared, holding a butcher's knife. It was the knife that, a moment later, cut off her scream.*
>
> *And her head."*

<p align="right">Robert Bloch, Psycho</p>

At one point in Bloch's 1959 novel, Mary Crane, a young lady trying to run away after stealing money from her boss, checked into the motel for the one night. Norman in a humble manner asks her to have dinner with him in the house. During dinner, Norma intrudes violently and threatens to kill Mary if he lets her stay under the same roof with them. Norman was stubborn and eats dinner with Mary anyway. However, he came out in anger and yelled at her when she suggested that he regulates his mother's behavior.

When Mary goes to her room to shower, Norman peeps through a peephole he drilled in the wall. He takes a bottle

and drinks until he became unconscious. While he was unconscious, Norma goes to Marry, takes control and be heads her. When Norman regained consciousness he discovered what Norma had done. Rather than reporting to the authorities, he puts the young lady's lifeless body in the trunk and drives the vehicle into a nearby swamp.

This was not the first time Norman was doing something so heartless, he had done this to two other women before Mary. As the psychologist struggles to help Norman improve mentally, the clinic introduces another character, Robert Newman. As chance will have it, he was Norman's twin brother who was taken away at birth after the doctor attending to him pronounced him brain damaged. As Robert and Norman learn more about each other, Norman, on his part, suspects a darkness in Robert, even worse than that which is said to be concealed in Norman himself. You'll have to read the book for more details.

After Bates gets arrested, he ends up back at the psychiatric hospital. Some may name this punishment anything apart from the just, yet readers were forced to trust that Bloch did well with regards to painting Bates and his identity issues to compel sympathy. Jail wasn't the best option for a man of this nature. Norman Bates required substantial mental assistance considering his crimes.

In the book's said chapters, before readers had to accept Norma's death, they had the opportunity to see that even Lila, as sad as she had been, came to acknowledge that Bates' imprisonment inside the mental facility was a better option to a regular jail. She understood the level of the insanity he suffered, and she enforces the example of Bates' personality conundrum that Bloch in Psycho's chapters.

The suspense in the novel is the most telling part of it all. Even with prior knowledge of Ed Gein, first time readers could not anticipate what would happen in the next scene.

The way the truth about Norma's death is revealed is indeed epic. It's no wonder, Bloch's hardcopy book has been in circulation for over 35 years and generated millions in revenue. It's practically the best ending Bloch could have ever offered readers. What's more? The more you read the book, the more you will come to appreciate the incredible mind and bold approach that Bloch took.

Psycho: The Life of the Fictional Character Norman Bates

Norman was the fictional character who played the role of Ed Gein. The character was developed by Bloch as an antagonist in the 1959 novel Psycho. Bates was a serial killer who kept the corpse of his dead mother while he aspired to become her. The first most significant difference between him and Ed Gein was that Gein did not keep the body of his mother even if he wanted to become her.

Bates was a semi-neurotic man with an extreme case of dissociative identity disorder. He could not bring himself to decide if he was a rational Norman, a little defenseless Norman or if he was his dead mother, Norma. He lacked control over his thoughts as he suffered from severe emotional abuse growing up. Just like Ed suffered in the hands of Augusta, Norman suffered in the hands of Norma, his mother.

Just like Augusta preached to Edward, Norma preached to Norman about how sinful sexual intercourse is claiming that all women except herself were prostitutes. According to the novel, the unhealthy relationship between Norma and Norman was active even before the death of his father, John Bates. They lived alone as though there was no one else in the world except both of them. When Norman reached adolescence, his mother met a man called Joe Considine and started making plans for marriage. This was the stimulus that provoked Norman and brought the monster inside to life. Out of rage-fueled with jealousy he killed Considine

and his mother, Norma. After he had killed them, he wrote a suicide note to cover up his crime. The picture he presented was that Norma killed Considine and killed herself afterward.

Norman was in shock after the incident and was hospitalized briefly. He subsequently developed a dissociative identity disorder, adopted his mother's personality in a bid to repress the awareness of her death and escape from the guilt he felt for killing her. He inherited her home, keeping her corpse and the motel she built while she was alive.

Norman's personality was different from Ed Gein's personality although this is probably because award winning writer Robert Bloch wanted to spice things up a little. Both individuals (fictional and real life) were emotionally immature because of the unhealthy relationships they had with their mothers.

In the case of several other real life psychopaths, upbringing and socialization played a significant role in their development. This proves that there exists a relationship between a child's social and mental development and the child's upbringing. This subsequently has an effect on the individual throughout their lifetime.

Ed may have been a sick man, but he was never really in control of his actions. Augusta was to blame. Considering his love helping others and the relationship he had with children, Ed would have made the perfect citizen. The events in his life turned him into what he became.

He witnessed the deaths of his family members one after the other including that if his mother. Soon after his mother died, he decided to change his sex, as a result he made a woman suit with human skin which helped him to be his

mother, instead an actual sex change.

Gein was seen to be insane and was no fit or competent mentally to stand a trial when he was arrested and was sent to the state's central hospital. He was later transferred to the state hospital in Madison. His doctor confirmed he was mentally fit to stand the trial where he was found not guilty.

Gein finally died of heart and respiratory failure due to cancer on the 26th day of July 1984 at a mental health Institute. He was buried in the Plainfield cemetery which was vandalized regularly by souvenir seekers until a large part of his gravestone was stolen in the year 2000. The stolen gravestone was gotten back at Seattle a year later and has been kept in properly since then.

Norman Bates, on the other hand, was one of the main characters featured in Robert Bloch's novel *Psycho*. Norman Bates's character was inspired by the body snatcher and murderer Ed Gein. Norman had a rough childhood as well.

As a child, he was abused emotionally by his mother, Norma, who always preached that sex was sinful and all women were prostitutes except her – just as Augusta had to Gein. Meanwhile, it was suggested that there were cases of incest between Norman and his mother. This was as a result of the both been alone all through after the death of Norman's father, John Bates.

After he murdered his mother and her lover out of jealousy, Norman made it look like a suicide scene. Later he took over the identity and personality of his mother to suppress his feelings of guilt. He also took over the mother's house and the family motel.

Norman was arrested after trying to kill Sam Loomis and Lila in the disguise of his mother. He was thus declared insane and sent to a mental institution. While in the psychiatric hospital, he killed a nun took over her character and

escaped. Going away like a hiker he attempted to hit the driver with an iron but was overpowered by him. This resulted in a fire accident where he died but the driver escaped.

Ed Gein and Norman Bates were both confused, delusional killers, with the later getting inspired by Ed Gein. While Ed Gein died as a result of heart failure due to cancer, Norman Bates died in an accident.

Robert understood the mind of a psycho. His ability to take Ed Gein's story and write the most epic novel ever is indeed commendable as the book *Psycho* earned the worldwide recognition it continues to get till this day.

> *"She was the only one left, and she was real. To be the only one, and to know that you are real - that's sanity, isn't it? But just to be on the safe side, maybe it was best to keep pretending that one was a stuffed figure. Not to move. Never to move. Just to sit here in the tiny room, forever and ever. If she sat there without moving, they wouldn't punish her. If she sat there without moving, they'd know that she was sane, sane, sane. She sat there for quite a long time, and then a fly came buzzing through the bars.*
>
> *It landed on her hand. If she wanted to, she could reach out and swat the fly. But she didn't swat it. She didn't swat it, and she hoped they were watching, because that proved what sort of a person she really was.*
>
> *Why, she wouldn't even harm a fly..."*

Robert Bloch, Psycho

Psycho the Movie

Phoenix, Arizona

Friday, December the Eleventh

Two forty-three P.M.

FADE IN: EXT. PHOENIX, ARIZONA - (DAY) - HELICOPTER
SHOT

Above Midtown section of the city. It is early afternoon, a
hot mid-summer day. The city is sun-sunblanched white and
its drifted-up noises are muted in blanched their own
echoes. We fly low, heading in a downtown direction,
passing over traffic-clogged streets, parking lots, white
business buildings, neatly patterned residential districts. As
we approach downtown section, the character of the city
begins to change. It is darker and shabby with age and
industry. We see railroad tracks, smokestacks, wholesale
fruit-and-vegetable markets, old municipal buildings, empty
lots. vegetable The very geography seems to give us a
climate of nefariousness, of back-doorness, dark and
shadowy. And secret. We fly lower and faster now, as if

41

seeking out a specific location. A skinny, high old hotel comes into view. On its exposed brick side great painted letters advertise "Transients-Low Weekly Rates-Radio in Every Room." We pause long enough to establish the shoddy character of this hotel. Its open, curtainless windows, its silent resigned look so characteristic of such hole-and-corner hotels. We move forward with purposefulness and toward a certain window. The sash is raised as high as it can go, but the shade is pulled down to three or four inches of the inside sill, as if the occupants of the room within wanted privacy but needed air. We are close now, so that only the lower half of the window frame is in shot. No sounds come from within the room.

Original Psycho script by Joseph
Stefano

The Making Of The 1960 Movie Psycho

In 1960 a psychological horror film was release. It would create a genre and perhaps become one of the best known horror movies of its generation. It was called *Psycho*. At the time no one knew how the film would develop into an iconic piece that was released numerous times with updated iterations. Regardless of how intense the new releases were, it was the original that shocked audiences worldwide and broke box-office records in the US, Britain, Asia, Canada, South America and France. Here is the story of how this film was created, promoted and received just five decades ago.

Inspired By the Book

As with many noteworthy films of the past, *Psycho* began first as a novel. Bloch was born in 1917 and became an American fiction writer who contributed to a wide range of genres. He was from the Midwest, a fact that would contribute to his eventual creation of the book. What made

Bloch such a good writer was his ability to weave puns into his works. Some of his titles are *Such Stuff as Screams Are Made Of* and *Out of the Mouths of Graves*. At the beginning of his career, he started with short stories and novels. What made him different from other writers though was the prolific list of works he created and how well he created psychological fiction.

Bloch's mentor at the beginning of his career was H.P. Lovecraft. Lovecraft was born in 1890 and was known as a horror fictionist. Though he himself was never commercially successful, he inspired many other writers, such as Bloch, to develop their writing skills. Although Bloch was at first following Lovecraft closely, he soon branched out with his own singular style. He began moving toward the direction of more psychologically-based thrillers and mystery stories. Slowly he started writing for the magazine *Weird Tales*. It was here that he developed his penchant for weaving together horror, shock and mystery. As a fan of many different science fiction fan-zines, he also began to contribute to them regularly.

Accolades began to add up quickly in Bloch's career. He was honored with the Hugo Award, the World Fantasy Award and the Bram Stoker Award. What made his creations so prolific were his continued foray into science fiction throughout his career. What made them unique were their inclusions of psychology. Though he himself was not a psychologist or ever a studier of the medium, Bloch was still able to understand and guide the reader into the true nature of the protagonist. All he needed was a continued stream of protagonists on which to build his ideas.

In 1957 about 40-miles away from where Bloch was born and raised, a disappearance started a long-standing search. The body was eventually located and the killer named Ed Gein was arrested. Bloch felt a story brewing when he heard of the crime. It was not the actual crime though that incited

his interest; rather, it was the psychology behind it. This is what gave him inspiration to pen two projects *Psycho* and two years later *The Shambles of Ed Gein*. The true story provided Bloch with his own protagonist, based on Gein, by the name of Norman Bates. Norman was a solitary man living in an isolated location. He grew up with a domineering female figure- his mother—who took over much of his psychology. Because of her, Norman was known to dress in women's clothing and had a shrine-like area of his home in her honor.

Norman Bates was the derivative of a real-life criminal, but with an accentuated focus on psychology. What made Norman tick? What profound happenings in his early years made him into the man he was during his grown years? What could push a man to this extent when millions of other people see abuses throughout childhood and go on to live "normal" lives? These were all questions that Bloch considered as he wove the intricate tale of "Psycho". In the movie Norman ended up being portrayed by Anthony Perkins, though in the book he was written much differently. In the book Bloch envisioned him as a portly, middle-aged man who was overcome by a fascination with "mother" due to her domineering personality. Liberties were obviously taken with the film, and they played to the surprise aspect of a good fictional murder mystery.

When it came to writing *Psycho*, there also was another influence throughout the book. Gein was the basis of only part of the story; so was Calvin Beck. Calvin Thomas was another odd character who found himself socially accepted for the most part. He was a part of the sci-fi social club that Bloch attended, though not a close personal friend. He published a popular magazine called "Castle of Frankenstein". What made him stick out in the mind of Bloch however was Beck's unnatural connection to his mother. She was constantly by his side, though he was a grown man. The circle of friends he kept rarely discussed it

though so as never to offend his feelings, or those of his mother. What was evident was that Mrs. Beck was a domineering, noisy, unpleasant woman who refused to give her son any time alone with his friends or by himself. One colleague was heard to say that he must want to "kill" his mother because of the intensely smothering and dominant role she took on with him in public and assumingly in private. She was known to accompany her son to his various classes and social outings.

When asked about his privacy as a grown man, Beck merely stated that he didn't care for his mother coming with him everywhere or her personality that domineered over him. Beyond an occasional statement like that though, he showed no real signs of aggravation or speaking up. Rather, he let her come with him on all errands and social engagements; he let her speak for him and against him publicly. It was obvious that he did not like her presence, but he never publicly disparaged her either. No one quite understood the reason for his acceptance and submission, but just assumed it was part of his personality.

What it did do though was complete Bloch's vision of who his next protagonist would be. Normal Bates would be a combination of real-life horror killer Ed Gein and psychologically-oppressed Calvin Beck. What is interesting though is to hear Bloch speak on the topic. He was repeatedly accused of using the real-life Gein as sole inspiration for Norman. Bloch however was quick to note the separation between the two, noting that Norman owned a hotel, he was involved with taxidermy, he kept his mother's body in his house, he adopted an alternative separate persona and he stuffed his mother for safe keeping. The real-life killer never did any of these things. Bloch added that Normal Bates was made out of "my own imagination". As with any prolific writer, the main character of *Psycho*, Bates, was a conglomeration of real-life, fictional and imaginary elements from a variety of sources. This is

why Bloch was so protective of dedicating the origins and founding thought process, to a real-life serial killer. Rather, he took his time to combine vivid pictures from his world that all led up to Norman's birth into the literary world.

At the time when *Psycho* first was released, Bloch was already a heralded writer. The same year the book was release he had already earned the Hugo Award for Best Short Story. He started his venture into alternative personalities with another short story penned in 1957, titled *The Real Bad Friend*. In addition, his story *Lucy Comes to Stay* also showed some of the basis for *Psycho*. Both stories played up the psychological portion of the storylines, a sign that this was where Bloch's interests were headed. Not only was he interested in the genre, but he also was adept at it. One by one his novels pointed to an underlying psychological theme driving the protagonist to do what they do; in the instance of *Psycho* that was the instinct to go out and "kill".

The Movie

When the story *Psycho* took root and became a novel, Alfred Hitchcock's assistant Peggy Robertson came upon it. As a long-time and respected assistant, she was able to bring projects to the director as she saw fit. Adding to her interest in the book was the fact that she noted some positive reviews and though it would be a good idea to show to him. In the end it was Anthony Boucher's review that spurred her to approach her employer with a fresh idea. At the time, Boucher was a very respected and influential editor in the literary world. He worked primarily for the San Francisco Chronicle and was a fan of the mystery fiction genre. Although he also was a writer, he had many other literary pursuits. He hosted a radio show, scripted radio dramas and continued to write himself. It was his editing, however, in the Chronicle that brought him the majority of his respect and notoriety. Both of which Robertson admired and made

her take note of his opinion.

At the time, Paramount Pictures had already passed on making the novel a movie. It was the belief of studio executives that the book was too "repulsive" to be a big budget film or to be a project they wanted to promote. They also held that it would not translate well to film for them. They had a certain budget and were very adamant about staying well within it; projects were vetted prior to earning a "green light". At the time though, Hitchcock was not ready to pass on the book, as if sensing some prolific creative possibility. It was said that once Robertson gave him a copy of the book, he became transfixed and read it and then re-read twice in the space of just one weekend. Hitchcock became obsessed and immediately paid Bloch $9,500 to purchase the book rights. What he knew at the time was that he was one of the top directors who was creating a buzz in the market and his opinion mattered. However, he also was not alone. There were other directors, from the US and around the world, who were hot on Hitchcock's heels, delving into the same genre that he was skilled with. He no longer was a "lone wolf" in the movie-making juggernaut. Rather, he was in danger of becoming one of many players. Though his ego likely didn't allow him to worry about falling into the possibility of being "one of many", he still was a business man. He understood being unique and the value it brought to his career and the box office. Because of this, he was always looking for new, exciting material to work with. More and more other directors were releasing projects that were being compared to Hitchcock's—with both positive and negative results. The bottom line was that the movie industry was changing and he had to change with it. If he stayed with the big budget glamorous thrillers that made his name, he would risk being left behind in a changing world.

At the time, he had already abandoned two projects for Paramount that were not working because of elevated salary

demands submitted by actors of the time. Hitchcock was not willing to meet the demands of the newer generation of stars.

> *"I never said all actors are cattle; what I said was all actors should be treated like cattle."*

<div align="right">Alfred Hitchcock</div>

Although they proved their box-office draws, he still was insistent that they be paid a fraction of what they normally commanded. During the late 50s in Hollywood Jimmy Stewart, John Wayne, Marilyn Monroe and Humphrey Bogart were all peacocking their fame. They were known around the world and their individual management insisted they be paid appropriately. Of course this left directors in the lurch. How were they to get the big Hollywood stars without going over budget every time they made a movie? This would eventually bring the 'old studio system' to its proverbial knees.

Paramount Pictures took a hard pass on *Psycho* the movie. Rather, they wanted Hitchcock to create one of his usual "star-studded thrillers" that played well to the general box office. Because Hitchcock was adamant about the project, Paramount pulled funding. Not one to be stopped though, he was rumored to mortgage what he had and call many favors in to get the project off the ground.

> *"It was looked upon by Paramount as a potential bomb and so the studio put every possible roadblock in Hitch's path. They gave him a small budget and told him there was no sound stage on the Paramount lot for him to use."*

<div align="right">Robert Bloch recalling the issues Hitchcock had to overcome to get the movie made.</div>

The Script

Joseph Stefano was the screenwriter who was hired to flesh out the script for production. Though he had little experience, he met with Hitchcock and was well-liked and respected immediately by the director. For the most part, he followed Bloch's original storyline with the exception of a few additions he created with Hitchcock. Originally Norman Bates was written as an overweight, middle-aged and obviously mentally unstable character. The screenwriter and director collectively made a change by suggesting that actor Anthony Perkins take on the role, thus changing the Bates' persona entirely.

One notable change in the updated screenplay was the elimination of a drinking habit prominent with the written book's main character. The screenplay showcased a Bates that was sober and no longer had components of occult, pornography and spirituality as did the book. It also eliminates Bates' early life and introduces Marion right from the beginning of the story. In fact, she is the first character the audience meets during opening scenes. While in the book she is introduced and a focal point for just two of the seventeen chapters, the movie makes her a central focus for more than half of its screen time. The book starts off with Norman and his life; the movie begins with Marion's life. This was a calculated decision to ease the viewer into her life. It was there to immediately start creating empathy for the woman, who within a few minutes would see her untimely end.

> *"The idea excited Hitch. And I got the job. Killing the leading lady in the first 20 minutes had never been done before! Hitch suggested a name actress to play Marion because the bigger the star the more unbelievable it would be that we would kill her. From there, the writing was easy. The only difficulty was switching the audience's sympathies to Norman*

after Marion's death."

Joseph Stafano

Another change was having Lila Crane look through Norman's personal items in his room. There is a particular book that she spies and starts to look at. Though the viewer doesn't see what is in the book, Hitchcock purposely filmed it this way. The goal was to create a psychological horror. What was in Norman's book? Surely it was some type of horrific pictures, but what? Hitchcock wanted to convey to the audience that "something" was not right with the situation, but they didn't know what...yet. The nuance of the scene had to be very subtle. The director wasn't aiming for a shock here. He was still building suspense. He was after all the *master of suspense!*

In addition, more changes were made. Marion in the book was originally named Mary. The romance between Lila and

Sam, Marion's sister and her boyfriend respectively, is eliminated. Reportedly Hitchcock wanted to focus on the storyline of mystery rather than an extraneous romance. Stefano also added a conversation between Marion and Norman that added to the sympathy felt for the villain. He, along with Hitchcock, believed it was needed to create audience sympathy farther on in the story post-murder. As was typical with Hitchcock he wanted to create a black-white motif within the film. Would the viewer sympathize with the killer? Would they look past what he did and still see him as the soft-spoken boy-next-door that was portrayed on the screen?

The novel is also notably more violent than the resulting film. In the novel, Marion is beheaded in the shower. In the film she is stabbed with that iconic scene where she makes a final reach for the shower curtain, pulling it down with her. Many of the decisions were made to allow Hitchcock to have filming options. It allowed for more depth and control over audience reception. Remember that he was never one to get a cheap thrill from his audience. Hitchcock made it clear that he was in it for the long-haul; he wanted the more difficult result- the one he had to work for. He wanted his audience to be drawn in psychologically to his work and value its deep-seeded message.

Casting

Hitchcock had no desire to play into the negotiating machine. Rather, at the time he had already made a name for himself as a big director. Many different actors wanted to work with him and some were willing to overlook the top-dollar salary for the opportunity. One was Janet Leigh. She was fresh off of portraying a successful slew of ingénues. Films like *Thirty Seconds Over Tokyo, If Winter Comes* and *Little Women* all featured the actress. In particular it was the later that made her a new star to Hollywood. She filmed *Little Women* in 1949 and it was a box-office hit. As the

character "Meg" it gave Leigh the acting vehicle she needed to solidify herself as a character actress able to play the sweet, innocent but central female character in a top-dollar film. In *Psycho*, Leigh was cast as Marion-the pivotal female role. She also was told that her character, though some considered the "female lead" would be killed relatively early on in the script.

Leigh was the second choice for Marion, though. Originally Hitchcock considered actress Dina Merrill for the role. He callously deemed her to have too large a forehead however to take on the role. She also was not as big a star as Leigh at the time. Part of the reason for casting Leigh specifically was to give the audience the idea that she would not be killed off anytime soon- but rather would last throughout the film.

Anthony Perkins was also well on his way to building a solid career. In 1960 when being cast in *Psycho* he had earned accolades already. His debut film called *The Actress* earned him a Golden Globe Award as the New Star of the year. His second film was *Friendly Persuasion*, for which he also received Academy Award nominations. He received a Tony Award for his stage work in *Look Homeward, Angel*. Though his acting prowess likely played a part in being cast as Norman Bates, it was more likely that Hitchcock approved of him because of his earnestness with acting and boyish good looks. It played perfectly into the horror of the film. It wasn't a gnarly, overweight frump that was commonly believed to be a quintessential serial killer; rather, it was the unassuming boy-next-door.

Remember that one of the main things that put Hitchcock in a category of his own when making films was his psychological build. While other directors focused on the script, scenery and lighting, Hitchcock concerned himself with an additional, more underlying aspect of film. What tools could he and his team use to truly startle the audience? How could they be kept on edge throughout the film until

the "secret" was revealed? Hitchcock successfully used sounds, lighting, camera angles, different cameras and even the actor's own physical qualities to keep viewers' psychologically tortured throughout the duration of the films.

Hitchcock rounded out his cast with some other important actors. Vera Miles took on the role of Lila Crane, Marion's sister. Miles was not as high-profile as Perkins or Leigh at the time, but she had a good history already. She originally had a minor role in *Two Tickets to Broadway* in 1951. The film starred Janet Leigh so the two had already worked together when they met on the set of *Psycho* in 1960. She also was familiar with Hitchcock already, having worked with him in 1958 on *Vertigo*. She became pregnant however and was forced to give up her leading role opposite James Stewart. It was rumored that Hitchcock held it against her that she was pregnant and had to pull out of the film. Retribution came during the filming of *Psycho* when Miles claimed that the director was difficult with her and purposely gave her unflattering wardrobe designs. Whether or not this was true has never been confirmed, but it was a lasting Hollywood rumor that withstood the test of time.

John Gavin came on board for the project to portray Sam Loomis. Gavin was another highly respected actor of the time. He had worked on *Imitation of Life* and *A Time to Love and a Time to Die* earlier in his career—turning in stellar performances in both. He was even voted as the most "Promising Newcomer" for his work in the later by the Motion Picture Exhibitor. Although his character was boyfriend to Janet Leigh's "Marion", he walked away with a very negative reflection on the experience. He stated that for the most part Hitchcock was "frosty" with him throughout filming, often complaining at the number of takes the actor required to get his lines the way the director wanted. The film was a hit and it did something to sustain Gavin's career, however he was never one to discuss it in a positive light.

He also claimed that the strong graphic nature of the film left a lasting negative impression on his own psychological health.

The detective Milton Arbogast was portrayed by actor Martin Balsam. Balsam too was a much respected actor of the time. He worked on the film *On the Waterfront* with Marlon Brando and Rod Steiger. He also was in *12 Angry Men* with Henry Fonda. His move to portray detective Arbogast was a carefully thought out one. Hitchcock stated that he wanted an actor who was believable as a detective, but not intrusive. In the end, he is murdered, so he had to have some vulnerability to him that played into a novice detective's misstep that led to his demise.

The cast was rounded out with character actor John McIntire as Al Chambers, Simon Oakland as Dr. Fred Richmond and Frank Albertson as Tom Cassidy. Each one was chosen as a key figure to build up the psychological suspense of the thriller. Hitchcock stated that his actors were important to continue to feed the suspense of his film.

The Filming

While Paramount Pictures made it clear that they did not want *Psycho* to be made, they did make their requests clear. What they wanted from Hitchcock was another star-laden big-budget mystery that followed the outline of his other successes. Originally they wanted Hitchcock to make *No Bail for the Judge* which was already scheduled and starred Audrey Hepburn. Hepburn became pregnant at the time though and this forced Hitchcock to abandon the project. He wanted to move on to the *Psycho* project, but Paramount was not supportive of it. Because of their negative stance against the film company denied Hitchcock his usual budget. He offered to rush it out of production using black-and-white filming technique and his own *Alfred Hitchcock Presents* television crew. The big movie studio wouldn't

budge on their decision though, telling him that their soundstages were booked and unavailable. Hitchcock took a proactive approach by offering to pay for the film personally and use his own production crew. His stipulation was that Paramount would agree to merely distribute the film. Instead of his quarter-of-a-million fee, he asked for a 60-percent cut of the film negative. Despite his own team being negative about the decision, he pressed ahead with his plan.

He ended up turning to his own funds via self-owned Shamley Productions and shooting at Revue Studios. Shamley Productions was a production company owned and originated by Hitchcock. He named it after Shamley Green, a village in Britain where he owned a country house. It was through Shamley that he produced *The Alfred Hitchcock Hour, Alfred Hitchcock Presents* and *Psycho*. Revue Studios was the MCA backlot, which was made up of a massive 360-acre area of Universal Studios. It was the center for producing such projects as *Wagon Train, Leave it to Beaver* and of course Alfred Hitchcock's various productions.

With the location and resources to shoot, Hitchcock took on the *Psycho* project alone- without the help of Paramount Pictures. It had a small budget of just $807,000. The goal was to make the film with a smaller budget, but still convey the outstanding psychological murder mystery that Hitchcock was known for. To do this, Hitchcock chose black and white filming techniques. He also used his film crew, his own composer and editor. He managed to keep his cost for production salaries down to $62,000. Janet Leigh and Anthony Perkins were both stars at the time, with proven box office draw power. Still, to stay under budget, Leigh was paid just $25,000 and Perkins was paid $40,000.

Janet Leigh was a big star at the time, who commanded a large salary. After reading the script however, she made it clear she was on board. One of the additional unique

characteristics of the film was to make a big-name star die off close to the beginning of the film. This was formerly relatively unheard of and Hitchcock was the first to treat a lead's part with such short screen-time. Anthony Perkins also was a big-name in movies. He at the time, was already an Oscar nominated actor having earned the accolade for the 1956 film "Friendly Persuasion".

The film was shot at Revue Studios, which was the same location Hitchcock used for filming his television program. In November of 1959 filming began. He used 55mm lenses coupled with 35mm cameras in an effort to mimic human vision. The purpose was to draw in the audience even more as they took in the psychological mystery tale. Remember that Hitchcock was a master at creating scenery that went far beyond just what was on the screen. This is what separated him from other film creators. He knew how to use all tools at his disposal to create the mood psychologically. Viewers were taken on a mental journey through his films that went much deeper than the superficial pictures in front of their eyes.

In 1960 Hitchcock was already a master of film and at the top of his game. Known as the "Master of Suspense" he pioneered many different methods of conveying suspense and psychological drama through film. Up until 1939 he worked in England but then he transferred to American soil to continue his filmmaking career. One thing that was evident in *Psycho* was his immediate and recognizable directorial style. Because the film was self-funded, he was able to imbue even more of his own film expertise into the picture. One tool he used commonly throughout his films and in this one was the movement of camera. It was a method of letting the audience engage in voyeurism on film. The flowing movement of cameras, rather than completely stationary, let the viewer feel as if they were moving along in the same room as the character on screen. Hitchcock also used strict framed shots to convey fear and anxiety. Just

think of how the camera shots were worked into the shower scene of *Psycho*. You rarely get a far-off vantage point; rather, he keeps the viewer close to the action, so as to draw them into the picture.

To complete the power of the film, Hitchcock had his assistant director Hilton A. Green scouted various locations. Each one was required to fit into the tight budget. Although the film itself was mostly made on set, there were reasons for external scenes. One was the film of Marion driving from Phoenix to Bakersfield in an effort to trade in her vehicle. Another outdoor scene was filmed of Marion sleeping in her car when the highway patrol finds her. Inadvertently, one scene shot in downtown Phoenix included Christmas decorations. Rather than reshoot the scene, Hitchcock opted to date the film during its opening scene as set in December.

In the end Green scouted more than 140 different locations to be reconstructed within the studio space. They included different homes and real estate offices that were to be used by Marion and Lila in the film. He also found a girl who fit the criteria of his mental picture of Marion and took pictures of her. He then handed them over to Helen Colvig, wardrobe supervisor, to replicate. This was a way to give realism to the character. The actual house belonging to Norman originated from a picture by Edward Hopper titled "The House by the Railroad". Green found the picture and believed it was just eerie and unique enough to be the ideal setting for Norman and mother to reside in.

The Normal Bates house and the Bates Motel were both created at Universal Studio's lot. The interiors were positioned on the same stage that *The Phantom of the Opera* set was located (now demolished as of 2016). This is a sign of how profound they were. The outside sets are still to this day, standing (though they have been moved and rebuilt several times). And though the *Psycho* film came out in 1960—more than half-a-decade ago—it still is an important

part of American film history. So important that it is one of the biggest attractions on the backlot tour to this very day.

For the film, both Perkins and Leigh were allowed to improvise, giving more character to the film. They were encouraged to use their imaginations to set the tone of their leads. One example is Norman's consistent eating of candy, which was a habit that Perkins developed on-the-spot and repeated from scene to scene. It was an ode to Norman's child-like innocence and boy-next-door charm. How could a mad serial killer innocently eat candy?

Hitchcock was not without his directorial tricks though. It was rumored that throughout filming he had numerous versions of "mother" hidden in Janet Leigh's dressing room. Leigh would enter the room and find mother sitting on a chair, in the closet, or in the bathroom. Leigh later stated that she wasn't particularly bothered by "mother" residing in her dressing room. She did wonder however if "mother" was there to find the scariest version of her, or if it was to keep Leigh herself on edge throughout filming. Hitchcock never addressed the debate. Interesting to note is that post-filming the skull of the version of "mother" used for filming was sent to the Musee du Cinema at La Cinamatheque in Paris France. French film curator Henri Langlois was the recipient of "mother". Hitchcock later stated that he believed that an American museum would "lose" or "sell" the piece of memorabilia so he opted for a French museum instead.

What made the production for Psycho different for Hitchcock was his need for retakes. Traditionally, he was not one to ever do a reshoot. Unfortunately, some scenes—namely the most memorable shower scene- required it. In this scene, there is a close-up of Marion's eye. Leigh had a difficult time with not blinking because of the water splashing in her face. The camera also had to be manually focused as the show was being filmed. The scene where "mother" is located also was intricate and necessitated

reshoots due to the heavy coordination that had to work perfectly. The turning of the chair, the light bulb and the flare all needed on-pointe management that proved difficult to capture.

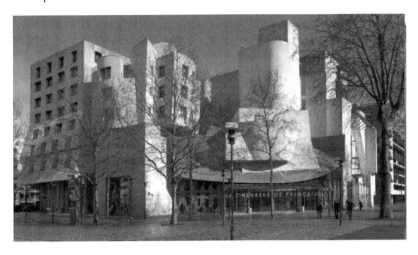

Musee du Cinema at La Cinamatheque in Paris

Another notable reshoot occurred when Arbogast, the detective, is seen creeping up the stairs at Norman's house just prior to his murder. According to Hitchcock, the gate used by Arbogast actor Martin Balsam was far too sinister; rather, Hitchcock stated the walk warranted innocence. He wanted the detective to merely be "doing his job" as he went upstairs, only to be caught off guard and murdered by Bates. Part of the issue also spanned to this murder scene. A camera was constructed on various pulleys high above the stairway. It was necessary to get the proper angle needed to capture the scene, without giving away the twist ending.

What also was unique to Hitchcock's style was using an attractive blond lead who was on the run from something. Part of the psychology of having this character was to paint a picture of juxtaposed guilt under the guise of innocence. It played well in *Psycho* because of Marion's guilt with

running off with funds and her weighing the option of doing the right thing. As is usual with Hitchcock though, before she can do the right thing another element comes to light— the twist ending. This is a signature tool the director used in his films. A thrilling plot that takes the viewer first-hand into the story and then surprises them with a twist. *Psycho* of course gives viewers the surprise with "mother" as she is revealed in her rocking chair and with Norman taking on her persona.

When filming Hitchcock made his usual appearance. In the picture it was him standing outside of Marion's office, standing next to his daughter who was also a bit player in the film. Hitchcock can be seen in a cowboy hat just outside the office window. This was another signature move by the director. He ensured the cameo occurred early into the movie as he did not want the audience distracted by trying to search for his unmistakable appearance throughout the movie. Contrastingly, he was also a highly visible character in film in many regards—making a name for himself through trailers, promotions and interviews. The cameo was just one more way that he set himself apart from other directors of the time.

That Scene In "Psycho"

By far the most recognizable and iconic scenes in the movie was the Janet Leigh shower scene. It is pivotal in the film, but it also is one of the best-known for its cinematography. There are more than 75 different camera angles used throughout the scene and it took seven days to film. Although the scene is just 3-minutes long, it proved to be one of the most arduous filming tasks, if not the most arduous, within the 1-hour and 49-minute film. Hitchcock's goal was to use the shower curtain as a visual tool to convey ripping and tearing apart. The knife's intense slashes and the sounds accompanying the 3-mintue long sequence were all built to affect the viewer on a deep mental level.

Understanding how impactful the shower sequence would be, Hitchcock was thought to have chosen black-and-white filming options partially to cut down on the gruesome color of blood flying at the shower curtain had it been done in full color. Even Hitchcock believed that the sight of blood and a murder may be a bit too much for the audience of the time. The red blood that splashes around the bathtub throughout the scene is actually Bosco chocolate syrup. It was used because of how well it showed up in the black-and-white film used. It was dark enough to shock and thick enough to be accepted as "real blood". Some viewers at the time claimed that they saw "red blood" frames scattered throughout the scene. This may be a heralding to *The Tingler* a film by William Castle from 1959. In this film the director used a color frame of red blood to shock the audience. Hitchcock confirmed that this was impossible. There were no additional color frames interspersed throughout the scene.

Part of the difficulty of the filming was the need for extreme close-ups for much of the content. Combined with a very short duration, this made a difficult task even harder. There are 50 cuts throughout the 3-minute timespan. The reason for filming like this was what Hitchcock believed to be a manner of transferring what is happening on screen directly into the psyche of the viewers. He believed that the fast-paced shots filmed close up made a much more impactful outcome than if filmed in a wider angle.

The direct-on shot of the shower head required a camera to have a long-lens attachment. The holes on the shower head were blocked so that the camera could be directed at the water, but the water would move around it. It also shot past the camera to give viewers the feel of being in the scene. One thing that added to creating the ominous feel was the soundtrack. This was appropriate to Hitchcock's directing. He wanted to always draw the audience into the film. They were not just viewing it; rather, they were experiencing it on multiple levels, not the most insignificant of which was psychological.

> "With Psycho, it might have been a heightened sense of mortality, societal violence, and moral responsibility. It was very unsettling to an audience to see a film where the star -- one they'd come to care for -- suddenly is killed halfway through the picture. Just a few years after the film came out, Americans were astonished and horrified by the much-publicized death of Kitty Genovese in New York City where she was attacked, yelled out for help, and nobody did anything -- even though many people heard her chilling, desperate cries. It was very upsetting, and it made everyone reconsider violence in our society and our responses to it. Maybe Psycho did something similar to audiences. Maybe it touched a nerve - and still does."

> Joseph Stefano

"The Murder" was the title of the piece accompanying the shower scene in *Psycho*. It was composed by Bernard Herrmann. Hermann was commissioned to compose the entire score, and originally was told that the shower scene would not need musical accompaniment. He asked Hitchcock to let him make an attempt at creating sound for the scene and in the end all parties were very happy with the result. Hitchcock even credited Herrmann with one-third

of the effect of the movie being attributed to his musical contributions.

Herrmann was originally commissioned to create a jazz score, as per Hitchcock's direction. The composer was hampered by a smaller budget than normal so he opted for a string orchestra, rather than a complete ensemble. He envisioned the single tones of the all-string composition as a method of efficiently matching the black-and-white tone of the film. All music in the film is created using a special muting device that was believed to create audible intensity and darkness.

The goal of the soundtrack from the beginning is to create a feel of pending violence and murder. It shows up immediately at the beginning of the film and then disappears from minute 15 to minute 20. Hitchcock stated that his goal was for the music to create the mood and then leave the audience hanging for the remainder of the time to see what happens as they anticipate tension. Herrmann also used screeching within his soundtrack. The goal was to match screeching with violent and vicious visual activity. Harshness was achieved by placing microphones close to the instruments to escalate their unpleasant delivery.

The true nature of the shower scene and how it was filmed was never officially confirmed. Some state that Leigh was in the shower herself, others claim a body double was used for the murder scene and some shots during the aftermath. Leigh herself stated that she was the only one used in the scenes, but later Hitchcock stated that a body double was used for some of the scenes. In the end it was revealed that Marli Renfro took on the role as Leigh's body double. Renfro was known for her commitment to nudism. For her body double stint she was paid $500.

> "I think the most daring thing Hitchcock did was to kill off the lead character, Marion Crane (Janet

*Leigh), in the first reel, that was the most shocking
thing in the film and is still considered an outrageous
notion in today's filmmaking circles."*

Saul Bass, a designer who storyboarded and, with
Hitchcock's assistance, directed the famous shower
sequence.

The screams heard throughout the shower scene were all by
Leigh's sole delivery. Though a popular myth stated that the
crew used icy water to create the shrieking, Leigh stated that
the crew used warm water and they were very
accommodating throughout the entire shoot. What is not
under contention however is the long-term impact the scene
had on the actress. It ended up affecting her real-life when
her then-husband Tony Curtis stated that beyond her
difficulty with showers, it also drove her to consume alcohol
much more frequently than before filming.

When watching the film, the viewer also heard stabbing
sounds on top of the music. Hitchcock achieved the sound
by stabbing various melons. Prop master Bob Bone was paid
to gather melons and then stab them as Hitchcock listened
with his eyes closed. After hearing a variety of fruits
stabbed—from watermelons to cantaloupes to casabas—the
director simply stated "casaba" and that is the fruit chosen as
the "winner". It offered the realistic sound of stabbing.

The shower scene is also one of the most studied scenes of
cinema school. Partially it is because of the enormity of the
number of frames within the 3-minute timeframe. Plus the
usage of camera angles makes it a joyous study for teachers
everywhere. It is a sign of the genius of Hitchcock and his
use of all tools at his disposal to create just the right resulting
effect for his audience.

"Bates Motel... 12 cabins, 12 vacancies."

Norman Bates

The Secrecy

Although casting was a large concern, so was secrecy. In effort to keep the ending a complete secret, Hitchcock purchased as many copies of the book by Bloch as he and his staff could find. During filming the set was completely closed and all cast and crew were under non-disclosure contracts. When Leigh found out that her character was to die early on, she was put on special alert. It was important that she never discuss her part, or its relatively short screen time. Hitchcock believed that if the media caught word that the main female character's part was so short, they would make the natural assumption - there is going to be a murder early on. It was his intent to keep all speculation out of the mix until the film was officially released in its entirety.

The reasoning for purchasing all of the hard copies of the book was to keep critics from rushing to read the ending. Hitchcock was afraid that if there were copies left on shelves and easy accessible, the worldwide critics would read the book and start to promote the storyline in mass to the public. This not only would ruin the ending, but it would ruin Hitchcock's desire to keep the audience in the dark. He wanted to guide them through the story with his own storytelling tools such as lighting, camera angles, dialogue, music, etc. He did not want outside influences to affect how the viewers digested the story. It was said that by the date of the release the cities of Los Angeles and New York had been almost completely ransacked by Hitchcock's staffers to prevent the critics from reading what happened at the end of the book.

Another well-kept secret was the movie's storyline. Hitchcock himself was known to share some misinformation about the movie prior to its release. One rumor was that he told the media his newest film would be titled "Psyche" but gave no additional information on it. Some of the media speculated that it was a tale of Greek mythology that

explored human nature. The director was likely happy with the misinformation. If the media was on the wrong track, it meant that his secret was still safe. The only other information he leaked out was that the story was of a mother who is a "homicidal maniac". Imagine the field day the press had with that—they spread the story that Hitchcock's latest story would feature a woman killer who was a mother. This was unheard of in the day and began the shocking media swirl around the project.

Hitchcock also refused to release any type of official synopsis to the media—an act that was unheard of at the time. Usually a director would release his own synopsis as a means of starting a buzz about the project. This led to media interest which led to more press which led to more box office numbers. Hitchcock was not fearful of this though. He never considered that it hampered his project; rather, he used it as a means to create more secrecy. The only other director who used this tool was Cecil B. DeMille who was tight-lipped about his release of *The Ten Commandments*. Though the press asked direct questions on how the story would play out, DeMille took to silence as his response. Both directors saw many gains as a result of their unique attitudes towards early release or insight into their projects.

In Hollywood it was always common to have the biggest stars promote a film—both at the earliest days of cinema and in modern-day movies. In fact, usually part of an actor's salary includes a contract spelling out the number of appearances they are going to make to properly promote the film. In terms of promotion, Hitchcock once again set his own rules in motion by forbidding the stars of *Psycho*—Janet Leigh and Anthony Perkins—from making public appearances about the movie on radio, in print or on television. Rather, the director decided that he would be the best spokesperson for the film's promotion. It was always common for directors to set up special screenings for critics. Their management and production companies would go

through pains to ensure luxurious viewing. In this case though, Hitchcock put a stop to that common practice too. He forced critics to view the movie on their own, with the general public. Though this was a risky move, his goal was to keep the details of the movie as secretive as possible up until the moment of general release.

Hitchcock was not completely withholding of information on the film however. He did tease the press with photos of the set. One iconic picture was of a director's chair that had the name "Mrs. Bates" printed prominently on the back. Each cast member was pictured taking a turn in the chair, except for Anthony Perkins. The pictures were released to create buzz about who Mrs. Bates really was.

The only additional nugget Hitchcock did release to the press was that in *Psycho* a woman would be a murder victim while in the shower. No other details were given. The press responded by asking how censors would allow for such an unheard of crime to be filmed and displayed. The director only commented that men have been known to kill "nude women". Though inundated with more questions, he left it at that.

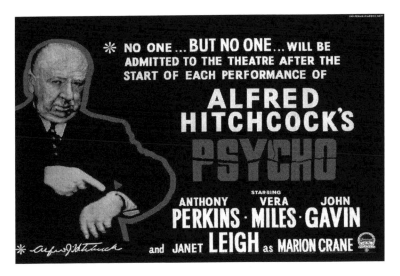

Despite his unique promotional plan for the movie, Hitchcock did put together a video to sell the film. It was a 6-minute trailer in which he narrated the crime scene of the story of the movie. It took the viewer on a tour of the Bates home and the Bates Motel on the Universal backlot. Carefully, it drew the viewer in to show them a relatively pleasant setting, though the house did look eerily dark- a sign that something was not as pleasant as it was being presented. The film ended with a woman screaming while in the shower. This scene was not the same one of Janet Leigh from the actual film. Rather, it was filmed completely separately with Vera Miles providing the woman's scream this time. It also introduced Hitchcock's firm policy of not allowing anyone in late once the film began running. They were cautioned to show up on time, or wait for the next showing. A tradition that is continued to this day, as before Hitchcock, people would just show up at theaters and watch whatever movies were playing, even if the starts had been missed.

Controversy

As with any iconic film, *Psycho* did not happen without some controversy. Graphic designer Saul Bass stated that he was the one who made the storyboards for numerous scenes during production. This was not in dispute, however he also went so far as to say that he directed the infamous shower scene. This has been vehemently denied by stars, crew and the director Hitchcock himself. Film expert and Hitchcock follower, Roger Ebert also denied claims citing that Hitchcock was too arrogant and demanding as a director to allow such a poignant part of his film to be captured by someone else. It would be completely out of character for an iconic director to let one pivotal scene go to the reigns of a completely unknown story designer.

> *"The whole design of "Psycho" was to reduce the violence on the screen as the film progressed and to*

increase the sense of violence in the audience's mind. By the end of the film I wanted the audience to actually feel the violence that they would never see on the screen. "

Alfred Hitchcock

Bass however was adamant throughout history that he filmed the scenes; even providing storyboards to prove his claims. Historian Bill Krohn studied the situation and stated that though the storyline followed the storyboards Bass created, they merely a lose framework of the actual resulting footage and scene. It was evident when studying that Hitchcock used two cameras to film the shower scene: a handheld French camera and a BNC Mitchell. He intended from the start to move from each one to create an emotional impact on all viewers. Though he took the framework of storyboards by Bass, it was his hand doing the recording, decision-making and editing.

Another controversy was the claim that throughout the shower scene, there is a shot of the knife actually penetrating Marion's body. This is not true. A frame-by-frame review of the scene shows that there is one shot where the knife does look as though it penetrates her stomach. There is a shadowy affect though created by both reverse motion and by the special lighting used. Leigh made statements post filming that the entire experience left her fearful of showering in real life. She stated it was a testament to how powerful a storyteller and director Hitchcock was; powerful to the point of adversely affecting cast and crew with the intensity of his filming.

She also expanded on scene's meaning stating that her character Marion made the decision to return to Phoenix and admit to her crime. Her shower was literally symbolic of a baptism, or rebirth and she stepped into it to show her true penitence. Corroborating her interpretation was film buff

Robin Wood. He stated that the shower was indicative of her long-standing guilt being ceremonially washed away through cleaning waters. He also stated that viewers interpreted the scene with a feeling of alienation, since the film's main character thus far was now gone.

In the end, it was reported that Hitchcock was not happy with the final version of the movie and was intent on using it as a television episode, rather than a feature film. After he gave the full project over to Herrmann's musical contribution, his mind was changed. When the film was done and set up alongside the music score, Hitchcock was convinced that it was the movie he wanted to make.

> "It's using pure cinema to cause the audience to emote. It was done by visual means designed in every possible way for an audience. That's why the murder in the bathroom is so violent, because as the film proceeds, there is less violence. But that scene was in the minds of the audience so strongly that one didn't have to do much more. I think that in Psycho there is no identification with the characters. There wasn't time to develop them and there was no need to. The audience goes through the paroxysms in the film without consciousness of Vera Miles or John Gavin. They're just characters that lead the audience through the final part of the picture. I wasn't interested in them. And you know, nobody ever mentions that they were ever in the film. It's rather sad for them. Can you imagine how the people in the front office would have cast the picture? They'd say, "Well, she gets killed off in the first reel, let's put anybody in there, and give Janet Leigh the second part with the love interest." Of course, this is idiot thinking. The whole point is to kill off the star, that is what makes it so unexpected. This was the basic reason for making the audience see it from the beginning. If they came in half-way through the

picture, they would say, "When's Janet Leigh coming on?" You can't have blurred thinking in suspense."

<div align="right">Alfred Hitchcock when interviewed by Peter Bogdanovich</div>

A Sign of the Times

The film was also a telltale sign of the changing atmosphere of the times in Hollywood. Throughout the 60s the Production Code was a moral guideline that was used by all major movie studios. It held up from 1930 until almost the end of the 1960s. Its purpose was to lay out exactly what was considered acceptable versus unacceptable viewable content for moviegoers. The code was strictly enforced throughout the time, although in the 50s independent film makers and foreign directors were challenging its content one by one. It originally was instituted because of some then-risqué films that were released in the 20s.

What made *Psycho* a direct opponent of the Production Code was its content. From the first scenes, it challenges code and its strict content. Even the opening scene of the movie was controversial. It showed Sam and Marion as lovers, who are in the same bed. Marion is wearing her underwear. Though now this is no longer a concern, at the time it was a jaw-dropping scene that was considered pushing the boundaries of "appropriate" viewing content. Not only were the two characters engaged in some intimate activities, but they were unmarried and sharing the same bed—a definite stand against the Production Code.

Another Production Code violation was a scene where censors stated that they could visibly see Leigh's breasts. They went back and forth with Hitchcock, who insisted that they were mistaken. After holding off any decisions for a few days, the director resubmitted the print and the censors seemed to change their minds across the board. Those who

saw the infraction, no longer did; those who didn't see it, now saw it clearly. Hitchcock removed a few additional frames that were in question and censors passed the film for distribution.

This was not the end of Hitchcock's struggle with the censorship board however. They were in arms about the overall violence of the film and raciness of the first few scenes. Hitchcock, always negotiating for his methodologies, stated that if the censors left his shower scene alone, he would agree to re-film the opening sequence with the censors present. They agreed, however on the specified day of shooting, they never showed up and Hitchcock left the opening scenes as they were.

> *"I think `Psycho' bothered people on a level that the horror films that came before and after never even attempted. `Psycho' gave us nice people who we learned to like and then forced us to watch them being brutally murdered by another seemingly nice person, Norman Bates, who was also easy to care about."*

> Joseph Stefano

Another scene that was in question was a scene where Marion flushes the toilet. This is pivotal because it shows the contents, which is a torn up piece of paper needed to solve the crime. At this time in history, toilets were not shown to the viewer. They were considered garish and uncouth. It would go down in cinematic history as the first flushing toilet ever seen on the big screen!

Hitchcock's film did not just see controversial reception with the US Production Code censors, but it also had some international opposition. New Zealand critics did not accept the shot of Norman washing his hands covered in blood. Singapore critics demanded the removal of both Norman's

mother's corpse and the murder of detective Arbogast. British critics cut the nude shots and the stabbing sounds of the shower. Though Hitchcock accepted the critics' statements internationally, he did stand firm on one policy: no showing up late. This was controversial because at the time, few had addressed the issue. Hitchcock had promotional posters created informing viewers to be on time. His goal was to ensure that every attendee would see opening scenes with Marion, portrayed by Leigh. Though theater owners were not supportive of the move, in the end they realized that it created more of a buzz about the film. Long lines were spied at their theater doors as a result of the promotion created by Hitchcock himself.

The Reviews

Although the film saw much success upon release in 1960, its official critical reviews were mixed. Some stated that it was obviously a "low budget production" and others claimed that it relied on "sudden shock" rather than good storytelling to get by. Still other critics claimed that both Leigh and Perkins put out the best performances of their careers. Others stated that they walked out mid-way through the film due to its violence and shock-reliant script. Overall the reception was so widely varied that it lost meaning though. The bottom line was that the public loved the movie and returned to see it over and over again. Regardless of what the critics said, as was printed in the New York Herald Tribune, the film was able to keep its viewers' attention much like a "snake-charmer" who directs the snake to exactly what tone and reaction he wants. Variety's reviewer wrote:

> *"Anyone listening hard enough, might almost hear Alfred Hitchcock saying, 'Believe this, kids, and I'll tell you another.' The rejoinder from this corner: Believability doesn't matter; but do tell another. Producer-director Hitchcock is up to his clavicle in*

*whimsicality and apparently had the time of his life
in putting together 'Psycho.' He's gotten in gore, in
the form of a couple of graphically-depicted knife
murders, a story that's far out in Freudian
motivations, and now and then injects little amusing
plot items that suggest the whole thing is not to be
taken seriously."*

As with many movies, the people viewing it were the ones
in power. After a phenomenally successful release date with
people loving the story, many critics changed their minds.
The movie continued to break box-office records throughout
France, Britain, Asia, the US, South America and Canada. In
the end, it was dubbed the most successful black and white
film ever created. Hitchcock ended up earning more than
$15-million in profits on the movie, which equates to about
$120-million in today's dollar.

In the end *Psycho* was one of most notable psychological
mystery thrillers in history. In fact, it has been referred to as
the first "Psycho"-analytical" thriller or 'chiller.' At the time
its groundbreaking content of violence and sexuality helped
to solidify Hitchcock as one of the most admired directors of
all time. In the end, the production walked away with an
Academy Award nomination for Best Director, an Edgar
Allan Poe Award for Best Motion Picture, a Golden Globe
Award nomination for Best Supporting Actress for Leigh,
Directors Guild of America Award for Outstanding
Directorial Achievement in Motion Pictures for Hitchcock, a
Writers Guild of America award for Best Written American
Drama and an International Board of Motion Picture
Reviewers Best Actor Award for Anthony Perkins.

The House

The History of the Psycho House on the Universal Studios, Hollywood Backlot

One of the most longstanding attractions on the Universal Studios backlot to this day is the Psycho House and motel below. Built in 1959, the house is iconic because it represents the psychological horror that was brought to the world thanks to Alfred Hitchcock, Norman Bates and of course "mother". If you have ever wondered how the house came to be and what happened to it, here is its story.

The Building

To showcase the film, Hitchcock was intent on creating a building that was suitable. He enlisted the help of assistant director Hilton A. Greene to find the locations needed for the film. One thing that played heavily on his mind was seeing Edward Hopper's "The House by the Railroad" painting. In the painting, a lone house is pictured. It is white and Victorian in nature, with a dark roof. This is the admitted basis for the house in *Psycho*, but there were many different influences as to its final configuration.

One rumored influence was a Victorian-era house in Kent, Ohio. Another was a hotel in Santa Cruz called Hotel McCray. In the official retelling of the making of *Psycho*,

both were denied. In actuality, the house was the brainchild of art director Joseph Hurley and production designer Robert Clatworthy. The two were inspired by Orson Welles' *Touch of Evil*, a film that was produced two years prior. Although "The House by the Railroad" was the official basis, both Hurley and Clatworthy made the house up out of their own design imaginations and experience. In California, the "California Gothic" house was very popular, as was the "California Gingerbread". These both played into the final design.

A fun fact that is not widely known is that the popular 1950 classic, *Harvey* starring James Stewart (who also worked a number of times with Hitchcock), was shot on Colonial Street on the Universal backlot (the street was also used extensively in the movie *Burbs* and the show *Desperate Housewives*). The actual top half of the whole house used in *Harvey* was carefully removed in 1959 and used as the top half of the *Psycho* house. A move that was obviously done to save as much of the budget as possible.

The house did provided Hitchcock with the perfect backdrop for his mysterious horror story. He used editing, framing, and lighting to make the house particularly eerie. The story carried its own mystery and suspense, so the house affiliated with it had to match. The Victorian facade played perfectly into the feel needed. After all, mother and Norman deserved a house as unique as they were.

The Resulting Tour

In the end, the movie was a smash hit. It brought in millions of viewers who were happy to experience the psychological thriller and its familial delivery. Critics didn't like the film at first, but when the public caught on and started to herald the movie, so did they. It solidified the Hitchcock film as one of the most poignant psychological thrillers in cinematic history.

The story was so important to the film world of the 60s that the "Psycho House" became a central focus. It was built in 1960 on the Universal Studio's backlot. The original purpose of course was for Hitchcock to have the right backdrop for his murder mystery's filming. Because of how big the movie was upon release, everything changed. All things relating to the movie created a huge buzz with the public. They wanted more "Psycho" and more of the horror experience that it begat.

The Psycho house in 2015 prior to a recent refurbishment.

Because of how popular it was, the house used for filming was never torn down. Rather, it became a central stop-off for the Universal Studio's tour bus. The tour lasts for about an hour and it travels up and down the many front lots and backlots of the studio. In each one, visitors are given a first-hand view of various movies and iconic scenery. The tour itself began back in 1915 and charged just 25-cents. Of course it has been updated over the decades, but since 1964 the Psycho House has remained one of the main attractions and something that visitors love seeing. In 1964 pink GlamorTrams were incorporated into the tour. The draw was that they provided viewers with a behind-the-scenes look into how movies were made. *Psycho,* along with *War of the Worlds, The Great Outdoors, How the Grinch Stole Christmas* and *Back to the Future* all found their place on the studio tour. Although each one has its own draw, to this day the *Psycho* house is still the one attraction that is most-talked about and most anticipated.

The house was constructed in 1959 due north of Singapore Lake (where Bruce the shark from *Jaws* pops up at passing trams), it would remain here until 1980. Whilst located here, the original motel was torn down and the house had only ever consisted of just two sides (the camera never saw the rear, so it was never constructed). Once additional side was added for the picture *Invitation of a Gunfighter* where the production needed more angles than Hitchcock had.

The house was partially dismantled in 1980 before it was reused in the Chevy Chase movie *Modern Problems* where the house was moved to the Santa Monica beach and painted pink. This temporary removal was timely as during the summer of 1981 a large mass of land was moved and levied to make way for more production space. By 1982 it was moved back to Universal (but not in the same location) and appeared in the show *Coming Soon* with John Landis and Jamie Lee Curtis; Curtis who's mother had famously appeared in the original movie all those year previously.

From this location it would remain until 1986. During the
spring of 1982 it was moved and re-erected with a rear
section and about 30 feet of motel for the preproduction of
the coming *Psycho II*. In 1986 it was moved for one final
time to its current location at the back of the lot adjacent to
Old Falls Lake (where the swamp scenes of the original was
filmed in 1959). Other than the Psycho franchise the house
and motel have been extensively used for the *Murder She
Wrote* TV series which was almost entirely filmed on the
Universal backlot. It was rumored to have been used over a
dozen times for the show in various guises, with Hitchcock
making a mysterious cameo appearance some twelve years
after his death (it was obviously a lookalike) in the episode
Incident on Lot 7; I am sure the great man would have
approved!

*The Hitchcock Bungalow on the Universal backlot where he
worked right up to his death and where in 1979 just 6
months prior to his death he was knighted by HM Queen
Elizabeth I.*

The house is in fact so important, that over the years the
Universal studio built a full *Psycho* house experience for it.
When travelers happen upon the house on the tour, they see
a slight man carrying a body out of the hotel. He puts the
body in the trunk of a vehicle and then stares ominously at
the passing tour bus. Slowly he starts moving toward the bus

as if to say "get away". Usually there is some shriek of terror as Norman nears the bus and the bus driver quickly drives away. In 2000, big-name star Jim Carrey even played into the fun. As the bus for the Universal Studios backlot tour crept up to the house, a figure appeared. It wasn't the normal Norman Bates though; rather, it was Carrey—star of numerous films—who leapt out and jumped on the bus in full "mother" garb. He ripped off a wig and started cackling, just like Norman's mother was known to do in the film.

The house and motel are also pivotal sections of Universal's now annual *Halloween Horror Nights*. For many years this section of the backlot is transformed every Halloween into the 'Terror Tram' where paying guests after dark get to walk around the motel and up the hill to the house. In recent years a photo opportunity with an actor playing Norman Bates is offered with a rotting corpse dummy placed in the window to represent 'Mother'. The area is often re-themed annually too, from modern hits such as *The Purge* to timeless offerings such as killer clowns.

This is sign of how popular the menacing movie has become. Not only was Universal Studio's benefiting from its creation, but top-billed stars wanted in on the fun. Also—the fact that Carrey joined in on the fun in 2000 and the film first came out 40-years prior, is a sign of how long-lasting its effect has been on the entertainment community. Not only did the movie frighten people at the time of its initial release, but it has remained a staple of the entertainment horror industry for decades and is still scaring people to this day!

Throughout the Universal Tour, what is anticipated by visitors is the *Psycho* house—looming in the background just behind the Bates Motel. It is this house that provided the spooky mystery the story needed. Though the house is just the façade, with no inner rooms, it still manages to instill a menacing feel to people who visit. People who just saw the

movie have a definite eerie déjà vu when seeing the house. It was after all the set for murder, psychological insanity and mystery.

Over the years the backlot tour has changed to incorporate many different attractions. Each time Universal sees a new blockbuster they try to recapture the excitement with a thrilling exhibit where visitors can experience their movie. *Psycho* proved its lasting significance with its overwhelming and consistent importance on the Universal Studios backlot tour.

If you are in the California area, be sure to take your own seat on the Universal Studio's backlot tour. Millions of visitors throughout the years have taken the same seat. Although now, the tour is equipped with technology now— LCD screens and better sound systems. It is a great time to enjoy the tour and you will love the eerie feel of coming back to the Bates house where the murderous rage of Norman Bates first began – albeit not necessarily in the exact same location!

Psycho ii

If there is one-thing movie goers have proven over the years, it is that they love a good thriller. Add psychological terror, and you likely have a hit. The movie *Psycho II* proved just that upon release in 1983. Though critics didn't support the film, or see much value to its continued storyline, audiences were thrilled to revisit Norman Bates and see how the old Psycho house and hotel were coming along after all these years.

The Writing Of Psycho II

In 1943 Tom Holland was born. Holland was a performer by nature, but would span into writing and directing throughout his 50 plus year career. Born in Poughkeepsie, New York, he would realize just after his high school graduation that he wanted to be in the entertainment industry. Throughout the 60s and the 70s he trained at Lee Strasberg's famed Actor's Studio under the iconic teacher himself. When it came to performing, Holland used the name "Tom Fielding" and found moderate success with acting roles in both film and on television. His biggest role of the time was working with Ingrid Bergman and Anthony Quinn on *A Walk in the Spring Rain*.

Though a burgeoning acting career was always in play,

Holland soon shifted most of his efforts into creating stories. He began with 1982's *The Beast Within*. Though the script was considered cheesy and a loose adaptation of a book of the same name, in the end it opened the door for Holland to do what he loved—write horror. Holland continued his career with another script called *Class of 1984*. His double foray into horror would allow him to create 1983 movie *Psycho II*.

The movie would prove to be one of Holland's most successful early films. In fact, it likely was the reason why he continued in the genre. From there he wrote hits such as *Fright Night*, *Child's Play* and *Thinner*. For television he contributed to the series *Tales from the Crypt*. Although he was officially a Hollywood writer, Holland also put himself into the *Psycho II* movie with a bit part as Deputy Norris. The storyline took up with Norman Bates once again to tell the next tale of "what ever happened to Norman Bates".

The Film Psycho II

The storyline follows Norman Bates and his continued struggles. If you recall, Norman was previously sent to a mental institution for his issues—not the smallest of which was his obsession with his always-present mother. Norman grew up with an overbearing mother who saw that her duty as a parent was to properly direct her boy at all costs. Although he was a man, she still had to make sure that she was always present to protect him and teach him what he needed to know.

What did he need to know according to mother? He needed to be aware of how morally objectionable women in general were. He had to be leery of outsiders, or anyone other than mother. He had to understand his priority at all times should be his family. Of course with only one known family member—mother—that clearly gave away her expectation of her adult's son life.

The film *Psycho II* is a tale of what happens when this kind of pressure is put on a son by his mother throughout his entire life. It is no secret that the mother-son relationship can be a complex one. With the overbearing emphasis on denying a son any other female relationship, what happens to a young man's psyche? This is the question that is explored throughout the movie.

The movie starts off with Norman Bates being released from the mental institution he has been in for the past 22-years. He has been confined throughout the time and under the care of Dr. Bill Raymond his psychiatrist. Upon release, he is taken back to his former home- the famed Bates home and Bates Motel. Of course this is much to the disdain of residents in the city who recall Norman as the killer of many people 22-years prior, one of which was Marion Crane. They come together to try to stop Norman's release and return.

Marion Crane's sister Lila Loomis appears. She started a petition to protest Norman's return and release from the institution. To no avail, Norman is placed at his old home. Upon arrival, he meets the new hotel manager named Warren Toomey. He immediately does not care for Toomey but bides his time. A job as a dishwasher and busboy at a local diner is set up for Norman as he assimilates back into normal society. When working at the diner, he meets the woman who operates it, Emma Spool. She is a kind elderly woman who takes to Norman and he likes her.

When Norman is at work one day he meets a co-worker named Mary Samuels, a waitress at the restaurant. Mary tells Norman that her boyfriend kicked her out of her home and she has nowhere to stay. He offers to let her come to the hotel and give her a room. When they get to the hotel, Norman realizes that the new hotel operator, Mr. Toomey, has turned it into a sleazy adult motel. Rather than have Mary stay, Norman offers to let her stay at the Bates house

instead.

Norman's life returning home is going well until one day his mother begins to contact him. If you recall, mother was discovered to be dead for many years and a victim of Norman's serial kills early on in his story. He receives mysterious notes from his mother while at his house and at work. He also received a phone call from mother when he's at home. Norman fires hotel manager Toomey after he starts a fight when at the diner. As Toomey goes to the hotel to pack, a mysterious figure in a black dress sneaks up behind him and stabs him to death.

With Toomey gone, Norman starts to put the hotel back in working order—as it was 22-years prior. He goes into his mother's old room and realizes that nothing in the room has been changed at all. It is exactly like he left it. Upon inspecting the room, he hears a noise in the attic and goes to investigate. He suddenly is locked in. While he is locked into the attic, a young teenage couple break into the house's cellar. They see a female pacing and decide to rush out of the house. As they try to escape, the boy is stabbed by the same figure in a black dress. The girl gets away and alerts the authorities of what happened.

Mary, who is still at the house, finds Norman in the attic. The sheriff arrives to ask questions about the missing boy. He searches the cellar, only to find it in perfect order contrary to what the teenage girl reported. The sheriff leaves. Norman starts to wonder what is going on and Mary tells him that she cleaned up the mess in the cellar. She tells Norman that she did it to protect him, knowing that if a body was found in his home he would be arrested and most likely returned to the institution. Norman collapses into a nearby chair and cries that "it" is beginning again. He feels that he is losing touch with reality and going mad again.

That night, Mary finds a peephole located in the bathroom

wall. She also spies someone watching her through it and calls for Norman. He comes up immediately and the two find a bloody cloth that someone tried to get rid of by stuffing it into the toilet. Norman, recalling his former days of confusion and murder, suspects that he is on another black-out murderous rampage but caught in his psychosis also. Mary returns to the motel and finds Lila who tells her that she is actually her mother. Lila also reveals that she has been calling Norman and pretending to be his deceased mother, even going so far as to dress like mother. She restored Norman's mother's room and was the one who locked him in the attic. Her goal was to convince Norman that he was going insane this time also and force him to be committed once again. There was a problem though—Mary realizes she has feelings for Norman.

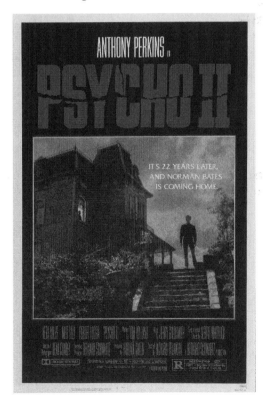

In the meantime, Dr. Raymond realizes Mary is Lila's daughter and tells Norman. He requests that Norman's actual mother is exhumed from her grave to prove to Norman that she is not haunting him or communicating with him from beyond. Mary tells Norman that she was part of the plot but now refuses to continue. She also vows to stop Lila from continuing to harass Norman. Mary goes to Lila's hotel and they begin fighting. Lila then returns to Norman's house but is unaware that Dr. Raymond is at the Bates Motel and sees her sneak into the house's cellar.

Lila snuck into the cellar to retrieve her "mother" costume. As she gets it, someone else dressed as mother murders her. Dr. Raymond finds her body in the cellar but no one else. Mary finds out that Warren Toomey's body was found in the swamp and she anticipates the police arriving at the Bates' house soon to arrest Norman for the murder. The phone rings and Norman starts talking to "mother" but Mary realizes that no one else is on the other line—Norman is talking to himself. Mary fears that he is going insane again. She runs to the basement to put on the "mother" costume so she can start talking to Norman. Grabbing a butcher knife, she runs to meet him. Someone grabs her from behind and she stabs the person. It turns out to be Dr. Raymond. Shaken, Mary runs to confront Norman but he is in a psychotic rage at this point. She defends herself, but ends up stabbing him numerous times in the hands and the chest. He and Mary slip into the cellar, where a pile of coal falls revealing Lila's body buried underneath. Mary believes that Norman is killing again. He denies it and blames "mother". She picks up the knife to make one final stab at him but the sheriff enters at that moment and kills her. The murderer, they decide, has been Mary all along.

The epilogue for Norman is his recovery. He is at home that night, bandaged and bruised. Emma Spool from the diner comes to visit. Norman gives her poisoned tea to drink. Emma reveals to Norman that she is his real mother and the

woman he believed to be his mother was her sister. Emma had Norman and was put in an institution for having her own problems, leaving her sister to raise Norman as her own son. She tells him also that she has watched over him his entire life and has always killed anyone who tried to harm him. He hits her in the head with a shovel, killing her. Then he takes her body upstairs, and dresses her as mother. Norman reopens the motel. The last scene is Norman standing in front of the house as mother is perched in the upstairs window spying down on the grounds.

There was a slight confusion when the book of the same name was released shortly before the movie. The book, penned by original writer Bloch, was in no way related to the movie with Bloch not aware that Universal was in pre-production of a sequel to their 1960 classic. A situation that did confuse matters with the public but ultimately pushed the movie into full production. Holland recalled:

> "I think the book sort of gave the impetus to making the movie. What happened was the book came out and the producer, Bernie Schwartz, now passed away, thought it was a good idea, and he optioned the book - but I'm not sure about that. Anyway when they calmed down and they read the book they realised it was impossible to make it as a movie but they had the idea by then. They needed to find a commercial story for the movie and they hired Richard Franklin the director, and then Richard Franklin hired me."

The movie would be shot almost entirely on the Universal backlot, excluding a scene at a nearby graveyard, for a humble budget of 3.8 million dollars. The original house was used for the production (albeit spruced up somewhat) and a small section of motel was built. The backgrounds and the rest of the motel were all added in post-production using matte paintings.

Throughout the filming of *Psycho II* one thing that was consistent was the lead- Norman Bates. Originally when the film was first written as a book the character was to be a rotund man who was aging. It was a directorial decision to turn the character into a younger, slim, boy-next-door type, personified perfectly by Anthony Perkins. One thing that Perkins brought to the role was that innocence and true desire to be a good son. As a man struggling with intense psychological and emotional issues, Perkins was the perfect person to carry out the depth of perceiving a person to be one thing, and having them turn out to be something entirely different. The movie plays with the concept of what is seen is not always what is there.

Interestingly enough, Perkins was not sold on taking on the iconic role for what was at the time the longest time between an original movie and its sequel. In fact, he said no to the role a number of times. It was rumored that Christopher Walken was offered the role post Perkins. Walken was known as a great thespian who could carry a film and portray a multi-layer killer—which was a must to do justice to the film and its legacy. In the end, Walken was the one who passed on the role when Perkins decided he would take on the famed character in his next format.

The lead female character also was in question during casting. Movie-makers and the studio thought that it would be interesting and an additional draw to have Jamie Lee Curtis portray Mary Loomis. Jamie Lee of course is Janet Leigh's daughter, and Leigh was the original star of the movie. She was murdered in the infamous shower scene, which turned out to be one of the most studies and discussed scenes in cinematographic history. As an ode to that, the studio contacted Leigh's daughter Jamie Lee Curtis. At the time, Curtis was known in Hollywood as the resident "scream queen" having starred in the hit *Halloween* in

1978, *Prom Night* in 1980 and *Terror Train* the same year.

Curtis was a big-name star of the time in the early 80s and her genre was horror, so it made sense that she would be cast in the *Psycho II* movie. Unfortunately, it did not work out and Curtis passed on the role. Kathleen Turner and Carrie Fisher both auditioned for the role, in the end actress Meg Tilly ended up taking the role. Tilly was just starting her professional career but had already starred in the 1980 film *Fame*, the 1982 film *Tex* and the 1983 movie *One Dark Night*. The later film began Tilly's foray into the horror genre and *Psycho II* solidified her interest and agility with the medium. In the film, Tilly portrayed Mary Loomis, an homage to "Marie Samuels", the false name that Marion Crane used in the original picture.

Rounding out the cast for the picture was Dennis Franz as Warren Toomey, the new Bates Motel manager, Claudia Bryar as Emma Spool, the diner owner where both Norman and Mary are employed and Hugh Gillin as Sheriff John Hunt. Though none of these characters were big-name stars at the time, they took on the character roles because of the interest of the film. For the most part, the cast was small, with just ten characters named- a sign of how much of the story revolved around the main character as played by Perkins.

Production

What made the movie so intriguing was its history of one of the best and one of the first psychologically-based horror films of all time. The second installation takes on the storyline where it would be in real-time. Viewers are given the image of where Norman is now—not immediately after the initial incidents that drove him mad. Having a 22-year break to recuperate is an advantage. Not only did it revive the former fun of the horror genre, but it also proved how captivating Norman was— a testament to Perkins' talents.

The solid and plausible storyline is also a sign of great film making. Returning to the former scene of the initial crimes, makes for the most interesting setting where viewers are given the opportunity to explore the intriguing character even more. Norman will not only have to face his demons in the "real world" now that he is being released, but he will be in the midst of all the former triggers that may send him into a world of insanity again. Will he be able to assimilate? Will he break down under the psychological pull of "mother"? Has he conquered his demons, or are they just resting for their next opportunity to strike? Perkins obviously has a field day with the questions, playing Norman as his usual harmless and seemingly innocent (though proven not) character. Though he harkens the character to the original Norman, he also imbues him with more layers this time around. All you have to do is listen to Perkins as Norman quivering his lines to camera, or acting as someone who has been under intense psychological therapy for the past two decades. The small nuances of what Perkins does bring depth to Norman, despite having been convicted and for all intense purposes, "a cold-blooded killer".

What also happened with Perkins' performance is that he was able to continue the viewer's attention-draw into his character. Initially though Norman was found guilty of murder, at no point did the viewer lose their interest or dispel him as "un-redeemable". There is a collective acceptance and hope for Norman that he may wrench himself free of mother's constant control, even from beyond the grave.

> Dr. Raymond: What's the matter?

> Norman Bates: Uh, I saw someone!
> Dr. Raymond: Where?
> Norman Bates: Up there! In that window!
> Dr. Raymond: I haven't had a tenant in the house for years.

Norman Bates: I guess I'm just nervous!
Dr. Raymond: Well, that's understandable under the circumstances.
Norman Bates: Yeah.

In *Psycho II* Richard Franklin took on the role of director. Prior to this movie, the Australian director took both the writer and producer role in the majority of his films. With few films under his belt at the time, Franklin was still well prepared for the directorial role. He was a lifelong studier and fan of Alfred Hitchcock. At the time of *Psycho II*, Hitchcock was already deceased, so having someone who could take on the story and do it justice was critical. Franklin was a good choice because of his former interest in the Hitchcock legacy. Before *Psycho II* he directed *Roadgames* starring Jamie Lee Curtis and Stacey Keech. The film was a nod to Hitchcock's *Rear Window* from 1958.

The writer Tom Holland had reservations about the script. Perhaps it was the iconic legacy that it came with, or possibly the expectation as a derivative of Hitchcock's brilliance that did not sit well with the writer. Franklin was concerned with doing justice to the film for the sake of carrying on Hitchcock's tradition and for the sake of creating a good movie. Regardless, he put the time and effort into creating the movie that was worthy of the title and the storyline.

During filming of the movie, the most intriguing element is further delving into the mind of the central character Norman Bates. What the audience wants to know is whether or not Norman has been cured, or is still struggling with his demons on a deeper level. By leaving the question open-ended for the duration of the film, the audience is left to make their own assumptions. Of course the audience expects murders—it is *Psycho II* after all—but who is the real culprit? Could Norman merely be imagining the murders and the phone calls? Or is someone really intentionally

messing with him? The reality is that whether or not he is guilty, Norman is a vulnerable man. He can be played for the good with the right influence, and for the bad with the wrong influence. Which is it though? Which one will he choose? Does he have a choice anymore, or is his evil innate?

What makes the movie so effective is its draw of the audience to empathize with the main character time and time again. No matter what happens, the viewer wants Norman to be proven innocent. They want the poor guy to get a break— he's had quite a childhood after all with a crazy overbearing mother. That landed him in a mental institution for the past twenty-two years, so it's about time Norman have some peace. The beginning led the audience to accept that murders were happening, but at whose hands? That was the question posed. This time, the question is "Is Norman alright?" That idea brings the story to a much more complicated place—rooting for the anti-hero in his frailty is always a psychological struggle. *Psycho II* makes the most of it with its combination of storyline, script, acting, music, lighting and special effects.

With this story though, the baggage Norman has amassed over the years is put aside quickly. For example, the start of the movie puts him directly in the iconic shower scene setting. You see Norman in the bathroom, taking you right back to where his story left off. It is reminiscent of his former story, but it also visually reminds the viewer that his story is not finished. He is carrying on, as everyone does after tragedy.

One of the ideas the movie capitalized on in its release is the notion that Norman may be instinctually a killer—a concept that was new to the movie industry at the time. In the early days of cinema, good guys were good guys and bad guys were bad guys. You knew immediately who was being set up for what and what their likely ends would be. It

was films like *Psycho II* that threw the ideal into a tailspin. No longer were things as one-dimensional as they had been presented. In this movie, everything from the motives of ancillary players to Norman's are in question.

The movie is not without some interesting Easter Eggs too. First, the appearance of Mary Loomis, now with the name Mary Samuels is a nod to Marie Samuels, a name Marion Crane used when signing into the roster of the Bates Motel. Another Second, Vera Miles is another actor who reprised her role, just like Anthony Perkins did. This is a happy reminder of where the film originated and how its story is not yet done.

There also are some scenes within the movie that are particularly noteworthy. One is the sight of a victim plummeting to their death down a staircase with a knife lodged in them. The force of falling on stairs push the knife deeper into their body—a frightening, if not uncomfortable, sight. Also, when Norman is being stabbed but believes it is his mother doing the stabbing, he repeatedly grabs to her for

an embrace. There is something bittersweet about a grown man who has been hurt and led astray so much by his mother, but still wants nothing more than to be close to her...even when she is literally stabbing at him with a butcher knife. It is scenes like these that are metaphoric and show you the tight rope Norman is walking psychologically.

The ending scene where Norman finds his "real" mother in Mrs. Spool and then kills her, is a sign of what he really wants. Rather than face the reality that "mother" is a little off her own mental centeredness, he would like to dress her up, place her in her chair and let life go on the way he so desperately needs it to.

Music

One of the most notable things about the "Psycho" creation was its music soundtrack. As created by Bernard Herrmann, the score played perfectly to creating tension, stress and uneasy anticipation with the audience. Just think of how an unwelcomed and unexpected sound at a critical moment in a film can send viewers out of their seats. Herrmann was a master at this. For the "Psycho II" movie, the same needed to happen; studio executives had to find the right musician to put the same power of sound to work. They found Jerry Goldsmith.

Goldsmith was a music prodigy from the age of 11-years old on. Working his life passion into his work, he was able to create numerous musical scores for the entertainment world prior to his work on *Psycho II*. In fact, by the early 80s, Goldsmith had already created compositions for a series of movies including *Star Trek: The Motion Picture, Freud* and *The Cage*, a Star Trek pilot. He had also won such prestigious nods as a Golden Globe nomination for Best Original Score.

As the 80s came about, Goldsmith noted his career moving

into the world of fantasy and science fiction. After writing for the 1977 series of *Star Wars* releases and *The Omen, The Secret of NIMH* and *Twilight Zone: The Movie*, he was tapped to create the soundtrack for *Psycho II*. What made his scores different was his inclusion of synthetic elements to the scores. At the time, it wasn't as common as it is now to create soundtracks using simulations, rather than actual orchestras. Goldsmith played with the concept and ended up continuing his career successfully through to 2004, the year he passed away.

Interestingly enough, Goldsmith first submitted a score for "Norman" and it was initially rejected by studio heads. They thought it was too "biting" and incited "too much tension" for the audience. Goldsmith, however recalled the studio's desire to stay true to the story of Norman and his former performance. In the end, his score remained. It included "The Murder" as created by Bernard Herrmann. Goldsmith added "Psycho II- Main Title", "Mother's Room" –part 1 and part 2, "Blood Bath", "Don't Take Me", "The Cellar", "It's Not Your Mother", "Psycho II- End". In between were various smaller pieces that played alongside the movie to capitalize on the current scenes and the emotional rise and fall of the story.

Reaction

When *Psycho II* came out, it was anticipated with both positive and negative notes. Would it do justice to Norman and his story? Would it be a cheesy horror film of the 80s? Universal Studios paid far less for the picture that others from that year. They used a variety of top-notch contributors to create a horror story that picked up on Norman Bates' life 22-years after his initial foray into insanity. The story was captivating, with people looking forward to what was going to happen with the character. From the beginning Anthony Perkins created a complex character who not only had quite an interesting life, but was able to incite plenty of sympathy

from his viewer—no small task considering his actions.

On opening weekend in June of 1983 the film earned over $8-million coming in second after the *Star Wars'* installment of *The Return of the Jedi*. With *Psycho II* on a shoestring budget like its predecessor, that puts it into the line of successful films right out of the gate. Universal Pictures and its executives were excited. Not only were the numbers high, but the critics were relatively supportive. Even the critics who were not completely positive with their reviews, still made it a point to focus on the various stand-out aspects of the film. Words and phrases like "darkly-comic" and "imaginative", along with "better than average in the slasher-film genre" were all used to describe the film. While it didn't get 10-out-of-10 stars on the majority of critics' notes, it did hold its own. This only added to the desire for the movie-going public to get their tickets for the movie.

In the end, Universal Studios saw a revenue of over $34-million with the picture. They drew people in with the enticing story and personal interest in Norman. It was not beyond the creators to understand that Norman was the center of it all. Director Franklin, along with writer Holland, wrote in plenty of chances for viewers to recollect the old Norman. He walks into the kitchen in one scene and puts his jacket on a chair. This scene was repeated from various vantage points throughout. Also, the final ending of the story was not even shared with the crew or the cast until the last days of filming. This was in an effort to keep everything about the movie quiet, and maximize its reception to the public. Finally, in the last shot there is a picture of Norman standing in front of his house. Crew members took that photo and used it as a Christmas card. Universal Studio execs saw the original one-sheet concept poster for marketing and didn't like it. Andrew London, who edited the film, suggested using that Christmas card photo as the one-sheet concept poster. Universal agreed and that is why it was put up. It included a tagline noting that Norman Bates

was "coming home". This was just enough to create the buzz about the film that added to its overall positive reception. People were intrigued by the poster—wondering if Norman was on his way back, what mental state would he be in upon his return? Did his 22-year stint at a mental institution do him some good? Or, would he return to his murderous ways? Did he ever settle his struggles with "mother"? All of these questions became enough of an impetus for movie-goers and slasher-film lovers to venture out and see what the buzz was about. Even though the film was releasing up against *Star Wars: Return of the Jedi* it was definitely not forgotten. The critics were also happy with the movie, with Variety saying, *"Psycho II is an impressive movie, 23-years-after follow up to Alfred Hitchcock's 1960 suspense classic."*

The other aspect of the film that was much appreciated by the viewer was its comedic backdrop. As the film was being put together, it was not without some off-key moments. Namely the scene where someone is killed with a shovel to the face is particularly jarring, but done in a "lighter" way. It isn't a moment of shock, but rather a moment of levity. How that is possible is a sign of how well the writers, directors and actors carried out the scene.

The film also played well on VHS and DVD. Times had changed in the past twenty-two years; when it was released DVDs were a large part of the movie-going world. Watching how well a DVD did was another sign of a truly successful film. *Psycho II* did not disappoint here either. Universal Studios leased the picture to GoodTimes Home Video in 1999 and its continued positive reception lived on.

Psycho II was a film that was much anticipated, it was had after all the title of being the longest duration between the original picture and its sequel. With the return to Norman Bates' twisted life, viewers wanted to find out exactly how the anti-hero was doing. The story follows him and his

continued struggle to come to peace with "mother". It proved to be a formidable entrant into the movie world with top-dollar showings and a moderate- to positive-critical review. The movie finally answered the question of where Norman was going and what really brought him peace. In many ways it would answer all the questions we had been left from the original but in turn would ask a whole lot more in its own right; this would ensure that the characters of Norman and "Mother" would not leave cinematic audiences quite so long before returning...

Psycho iii

The year was 1986 and *Psycho III* was a welcomed new addition to the world of movies. What made the film so anticipated was the mythology behind Norman Bates. Norman, after all, had thrilled audiences with his story. A handsome, innocent-looking boy-next-door-type who was plagued by a domineering and abusive mother. In the end, he murdered her and quite possibly it was the oedipal nature of the crime that had audiences repeatedly abuzz. Regardless, it made for one of the most exciting movies of the 80s that is still considered a staple in the horror genre.

The Production

The *Psycho III* story is one the centers on the new story of Norman Bates. He was referred to as the "world's most infamous mama's boy". What makes Norman so compelling is his dedication to following mother. The struggle he goes through is palpable. It also is what makes so many people in the film industry want to work with the story.

In terms of *Psycho III*, it was directed by Anthony Perkins himself, making his directorial debut. This is a highly impressive debut too. What you'll notice most about the film is the various tools Perkins uses to set the tone of the movie. This isn't a production that relies solely on one note. Many

films in the 80s relied on the script or the actor's performances to carry the message. What is different here is that Perkins uses those, but adds on the specific tools all good directors use; namely lighting, sounds and camera angles to create the picture's unsettling tone – which is no easy task for a first-time out director.

> "Some people have already begun referring to me as a director, but being a first-time movie director is a bit like being a first-time bullfighter. You can find out all about the ring and the people who'll assist you and the outfit you wear-but until you get into that ring with the bull you can't call yourself a bullfighter! And when that word filtered down to Universal, they did everything they could do encourage me. It's a question of affinity with the material. And I know this story. I should. I've lived with it-and sometimes tried to live it down-for more than 20 years!"

> Anthony Perkins

One fun thing you'll notice about Perkins' directing is that he breaks the fourth wall throughout the performance. This was a decision made most likely due to him taking the helm at directing and bringing his understanding of Norman to the work. You'll see Norman face the camera directly, staring intently into the eyes of the viewer. This is a compelling manner of delivering the various scenes and really makes the viewer think that Norman just may be talking to them.

Perkins is definitely the most involved and knowledgeable when it comes to understanding Norman. Because of this, why shouldn't he be the one delivering his message with directing the picture? You'll enjoy how this picture has a personal element to it. Rather than thinking of Norman as merely a character up there on the screen, you'll want to know how the "mama's boy" is doing. You'll want to follow his story to see if he finally has wretched himself free of

"mother", or if he's still at his old ways.

Another element of making the *Psycho III* film that shaped it was using Charles Edward Pogue Jr. as the screenwriter. Pogue was a successful writer, playwright and actor throughout the 80s and 90s. He began his career with writing his own adaptations of *The Hound of the Baskervilles, Hands of a Murderer* and *The Sign of Four*. Each one had its own mystery theme to it, making it the perfect training ground for more projects of the genre. What makes Pogue effective as a screenwriter is his attention to detail. For example, in *Psycho III* he was the one who included the detail of Maureen being a lost nun. Imagine that—Norman Bates dating and liking a former nun! And what's more, being liked by a former nun. The connection was not an accident. Pogue purposely created the diametrical opposite of Norman and then put them together as a love connection. What is interesting about the coupling is that Maureen knows everything about him—she knows about the institutionalization, the murders and the accusations that continue. Still, she believes that they are meant to be together. And they would be, if not for mother calling Norman's name as just the wrong moment. Again-Norman just can't get a break.

The story is built on opposites. Consider boy-next-door Norman is a cold-blooded killer, Maureen the ex-nun that falls in love with a serial killer, and Tracy the busy-body reporter interring with Norman and their lives. The story is not common and has enough unlikely plot twists that it keeps the audience's attention.

The story was supported by Universal Studios, a Studio that has been behind Norman for a long time, having purchased the rights to Hitchcock's entire back catalogue after his death in 1980. With this iteration, they were willing to take a chance at the new director Anthony Perkins. The studio realized from the beginning that he was someone who has

been with the character longer than anyone. Who better to tell the story than him? Not only did it give a true delivery of the character's story, but it also gave a natural depth to the entire film. It is often said that a director paints the picture through their eyes. This is one of the most interesting stories told through the eyes of the star.

Interestingly enough, Perkins said that there was some concern over the picture for him. The film was a generation of the series that carries on the long-term mythology it has built over the years. That didn't make it as popular or desirable to work with as one might think. In fact, Perkins reported that it was difficult to get people on board at first. What ended up selling the film and finding the right professionals was Perkins and his passion for the character. What was nice though was Universal's commitment to the project and support of their star and director. Perkins confirmed that once he was on board, the Studio was quick to give him the resources he needed to tell the story.

> *Norma Bates: Put me closer to the window.*
> *Norman Bates: Someone will see you, Mother.*
> *Norma Bates: Are you ashamed of me?*
> *Norman Bates: You know why, Mother. They've even written about you in the newspapers.*
> *Norma Bates: Stop your whining, boy. All this fuss over nothing.*
> *Norman Bates: Not nothing. I-I saw her. Even the initials on her suitcase, "M.C." Marion Crane.*
> *Norma Bates: Another of your cheap erotic delusions, out of your cheap erotic imagination. You killed her. The slut deserved it. But she's dead and the dead don't come back.*
> *Norman Bates: Y-Y-You came back.*
> *Norma Bates: I never went away don't you know that by now? You can't get rid of me. I'll always be with you Norman. Always. Stand up straight and wipe your snotty little nose. If the disgusting little*

whore is going to upset you so much, just get rid of her.
Norman Bates: No!
Norma Bates: Then maybe I will.

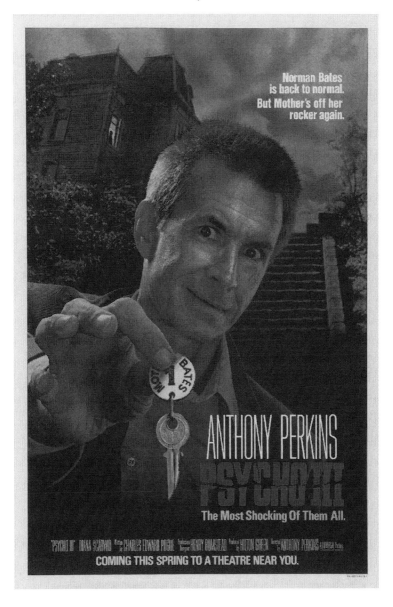

As with *Psycho* and *Psycho II*, many theatrical rules had been broken and then established with these pictures, *Psycho III* would continue this tradition. Namely, Norman Bates was the challenge the market needed. *Psycho III* also brought in Diana Scarwid as Maureen Coyle. She is a key character because she is the trigger that Norman plays off of. As a visitor to the town of Fairvale, her initials are "M.C.", which is an homage to Norman's other kills by the name of Marion Crane, of the infamous "shower scene" fame. In fact, when he first sees Maureen Coyle in the diner, they lock eyes and he has an immediate flashback to the shower and the woman he violently murdered decades earlier. Scarwid stated that she took the role because of the layers it offered. She was portraying a suicidal nun, after all. What better acting content could she find than that? Her character matched with the dichotomy of the film. The "good guy" is a murderer and the "nun" is suicidal. Add to that her obvious similarity to Marion Crane and it was perfect casting for the actress. Her blond hair, blue-eyed look was perfect because she looked innocent. Scarwid was a long-time working actress at the time. She had already famously portrayed Christina Crawford, Joan Crawford's daughter in the hit *Mommie Dearest* five years prior.

The interesting thing here is to watch the connection between Perkins' and Scarwid's characters. There is a lot of levity between them and it gave the writers the chance to create some comedic moments in the script. For example, when Norman brings Maureen to the hospital after she tries to commit suicide, she apologizes for it. He says that he doesn't want the establishment to "have a bad name", a reference to all the controversy of the motel over the years. She also tells him that she feels "mad" and he says "We all feel a little mad sometimes". Those who are aware of the mythology of Psycho know this line well. It was one that mother used to justify "her" kills.

Added to the cast also was Jeff Fahey. Fahey portrayed Duane Duke. He is the character who comes into town with Maureen Coyle, but kicks her out of his car. He comes to the Bates Motel and asks for a job after seeing the "help wanted" sign. He is a biker and set up as the "assistant manager" to Norman.

Roberta Maxwell played Tracy Venable, the newspaper reporter who was in search of a good story on serial killers. Prior to her role in the film, she was for the most part a Shakespearian actress, featured in productions like Twelfth Night, Much Ado About Nothing and The Merry Wives of Windsor. She is perfect as the snoopy and determined newspaper reporter in the film. Her puckish portrayal is exactly what is needed.

Rounding out the cast with smaller parts are Hugh Gillin as the Sheriff John Hunt, Lee Garlington as Myrna, Donnovan Scott as Kyle, Jack Murdock as Lou, Robert Alan Browne as Ralph Statler, and Juliette Cummins as Red. Though none of these actors were very well known at the time, they were the idea bit players to carry the plot forward.

In attempt to make his directorial role slightly easier, Perkins used Kurt Paul his long time body double as much as possible. Paul even learnt the part in full and would act our scenes with the cast in character. Perkins said at the time of production:

> "He'll actually learn the lines and know the role
> thoroughly, that way I'll be able to see how it all
> looks. Kurt's going to be a big help. And there's a bit
> of Norman in him too."

Paul also starred in *Psycho II* and after this picture would appear *Psycho IV* and many other shows in the role of 'mother' or body doubling for Anthony Perkins whether in parody or in straight parts too.

The Plot

Psycho III finds Norman Bates well. In fact, he is relatively set up again at his old job, the Bates Motel, and the eerie Bates' house. The movie opens with a mysterious couple traveling down a deserted highway. They are obviously confused about their whereabouts and new companions. They drive through the night and suddenly it starts to rain heavily. The man, who is the driver, has a hard time keeping the vehicle on the road spins out. He pulls over, much to his female companion's disappointment. She asks why and he tells her he isn't driving any farther in this inclement weather. It pours rainfall night and the man makes lewd advances towards the woman. She ends up slapping him and running out of the vehicle into the rainy night.

In the morning she ends up walking down the road and happens across the Bates' Motel with a "help wanted" sign. She immediately finds dead birds laying on the ground beneath a bird feeder. A sign perhaps that Norman is at it again. Inside the house he is working on his hobby of taxidermy with a…bird. He's eating crackers at the same time, an obvious reference to how well adjusted Norman is to death. Things that other people would find horror with, Norman is fine with.

The camera also pans to the newspaper where a missing woman is headline news. Her name is Emma Spool. Emma Spool formerly told Norman that she was his real mother and upon informing him, he hit her over the head with a shovel and killed her. The camera next shows Norman working on sewing a human hand. At the same time, a paper bag in front of him starts moving. He's concerned at first, but then realizes a bird has wandered into the house and was in the bag. Norman takes the bird and sets it free. Perhaps this is a sign that there is part of the serial killer that wants to respect life. It offers an insight into Norman though that lets the viewer know that there are still things that spook

him. Perhaps Norman is afraid of the things he did and some pending retribution from beyond that may one day find him. Regardless, he has a nice chuckle when the live bird flies out of the bag.

The man in the vehicle ends up pulling up to the Bates Motel also. He wanders inside the office, to find an open register with money. Just then, Normal walks up behind him and they joke about someone stealing the cash that is left in the open. The man introduces himself as Duke and tells Norman that he cannot afford a room there but is interested in the "help wanted" sign. Norman tells him that there is work at the motel but they have been undergoing renovations. When they go to shake hands, the man notices that Norman has "red paint" on his hands. Norman goes to clean up.

He offers the man 5-dollars an hour to work as the general assistant of the motel, with a free room. He informs Norman that he is interested in filling in until someone permanent is hired. He tells him he is a musician who just wants enough money to fix his vehicle to get to California and resume his musical career.

With that Norman heads down to Statler's Café, the diner Emma Spool owned. In the diner, a police officer and the owner-cook are talking about her. The report that her apartment is in order, nothing was missing; the woman just disappeared and has been gone for over a month. The cook states that in the 7 years she's worked there, she never was never absent. A woman sitting at the bar notes that Norman Bates was around and the rumor is he has a thing for elderly women. The police chief said that this is only a rumor and Norman deserves a second chance. The cook and policeman agree that he paid his debt to society and now should merely be left alone. While they are talking, a woman walks in and starts disagreeing with them.

Just then, Norman walks into the diner and sits down. The woman approaches him and introduces herself as Tracy Venable, a journalist looking to write an inside-view of serial killers. Her position is interesting because as per her latest assignment, she is doing a piece on the rehabilitation of murderers and the insanity plea. She believes discussing it with Norman would be perfect. She says that murderers are "victims too" and wants his point of view. She explains that Norman was committed for 22-years and he paid his debt, but then Marion Crane's sister Lila still tried to prosecute him. As they are talking a woman is dropped off at the front of the diner. Norman sees her and is immediately struck by her similarity to one of his central victims. What is interesting about the scene is Tracy's is her opening the dialogue with the possibility of Norman being a killer, but still deserving another chance in life. It is as if the film itself is trying to explore the life of a murderer, how he or she finds peace and what they deserve after they are rehabilitated.

Tracy continues her dialogue and mentions the disappearance of Mrs. Spool. She poses the question of residents accusing him of her disappearance, or having something to do with it, because of his history. (As an interesting side note, when Ms. Venable sits down at Norman's table, the waitress comes and places his usual, a glass of milk. Perhaps a nod by the director, or perhaps a coincidence, but the milk is an interesting choice. It reinforced the notion of Norman being a "good" boy.) Just then, the woman who was dropped off walks inside. Her suitcase has the initials "M.C." on it, which is reminiscent of Norman's earlier murder twenty years ago of Marion Crane. Crane was the victim in the iconic shower scene and Norman relives it as he sees the woman sit down at the counter.

Norman gets nervous about the questions from Venable and the woman who looks like one of his victims and gets up to

rush out. As he does, the woman who walked in asks the waitress if there is a place to stay close by. Norman rushes out and a picture of Mrs. Spool is on the door.

In the next scene, viewers are taken back to the Bates Motel where the woman with the "M.C." briefcase comes walking in. Of course the man who kicked her out of the car the previous night, is now working there. He greets her and gives her Room #1. Norman spies her arrival from the Bates' house. She introduces herself to the assistant manager as Maureen Coyle and pays for the room.

Norman comes down to the motel and eerily stands at the side as Maureen enters her room quickly. He then goes to speak to Duke. Norman seems shocked when he notes that Maureen was given Room #1 and rushes back to the house to discuss it with "mother". He is telling mother that she was written about in the newspaper and he tells her about Maureen Coyle. Of course, mother is not uplifting; she's her usual morbid mother persona. She reminds Norman that no matter what, he can't get rid of her. She also tells him to get rid of Maureen and he won't, she will. In the meantime, Maureen is settling into her motel room but is obviously troubled. She sees the Holy Bible on the end table and immediately starts crying, remembering some past offence. Norman removes a painting, only to reveal a hole in the wall, directed at Room #1. He peers through and sees Maureen undressing. Suddenly, mother's hand opens the door and she's holding a butcher knife in the other. She walks slowly into the bathroom, where Maureen is taking a bath. She tears back the shower curtain to reveal Maureen in a bathtub of blood—she has slit her wrists with a razor blade.

That night Duke wanders down to the local bar where he meets Tracy Venable. She rudely refuses his advances, but notices he has a matchbook with the Bates' Motel on it. She offers to buy him a drink. The two discuss Norman and

Tracy gives Duke his full history of criminal activity. She makes a deal with Duke and pays him to give her any information about Norman he can.

Maureen is next seen at St. Matthew's Hospital with Father Bryan watching over her. Norman is in the waiting room and so is the sheriff. Tracy arrives and starts asking how Norman knew Maureen needed help. The sheriff defends him by saying he was bringing towels to the room. At that moment, Maureen tells the nurse she wants to talk to Norman. He goes into the room to see her and she recognizes that he found her. She introduces herself to him and thanks him for saving her. He jokes that he doesn't want the Bates' Motel to have a bad name. He tells her she can stay at the motel for as long as she wants free of charge, noting that it might give her the chance to clear her head.

Norman returns home and starts one of his infamous arguments with mother. She voices her desire for Maureen to have died and Norman voices his thankfulness that she didn't. At the same time Duke brings home someone from the bar. She's seen outside at the ice machine trying to wrench it open, but it is locked. Norman comes down to open it for her and she invites him to come to the room with her and Duke for a party. He declines, but is obviously intrigued. She returns to the motel room and insults Duke. He kicks her out of their room. She goes to the payphone to make a call, but suddenly mother appears with a butcher knife and murders her in the darkness. He then goes upstairs to the house and can be heard screaming "Mother- blood! Blood!" The following morning Duke wakes up and sees Norman washing out the phone booth.

> Norma Bates: You dirty, dirty boy!
> Norman Bates: But I... I didn't do anything, Mother...
> I didn't do anything, Mother. She's a nice girl.
> Norma Bates: She's a whore.
> Norman Bates: But we didn't do anything.

112

Norma Bates: You let her come between us.
Norman Bates: But this... It isn't right. It isn't natural.
Norma Bates: It's perfectly natural for a son to love his mother.
Norman Bates: God, will you leave me alone, Mother? Will you leave me alone?

In the next scene, Maureen is talking to a priest. She reveals that she was a nun, but is having difficulties with final vows. They discuss the attempted suicide, but the priest tells her that God saved her twice from dying. She describes the vision of Mary Magdalene when she was lying in the bathtub. She also remembers the vision holding a silver crucifix, which of course the viewer knows was Norman's knife. Norman brings Maureen back to the motel and sees Ms. Venable walking up the stairs to the Bates' house. She asks to finish their dialogue from earlier. He refuses and asks her to not return. When Maureen returns to her room, she realizes that Norman had her clothing cleaned for her.

Tracy Venable is on the road with her investigative nature. She goes to Mrs. Spool's old apartment to see if she can dig up anything about the woman's whereabouts. After looking through the missing woman's things, she notices a phone number written on a magazine. She calls it and it connects her directly to the Bates Motel where Norman answers. When no one responds, Norman is seen getting ready for a date with Maureen later that night. He tells mother about his plans and reminds her that Maureen is "a nice girl". Of course mother is having none of this and refers to her as a "whore", because of course to mother all women are whores.

On their date, Maureen and Norman have a great time. They immediately like each other. Norman even seems relaxed with her and willing to take the lead when dancing. Though Maureen doesn't know how to dance, Norman gives her a simple dance lesson while out on the floor. It is a tender

moment where you can see that the two like each other. Later that night, the two end up at the motel, where a raucous party is underway. Norman and Maureen retire to a room and start a romantic evening alone. Though in the end he is not interested in consummating the relationship, Maureen still asks him to lay with her for a while. They fall asleep.

Patsy is another guest of the raucous party and she meets her untimely fate thanks to mother. Later Norman finds the body and nervous, he quickly throws her body into the ice chest in back of the motel. The following day, the sheriff and his deputy come to the motel to investigate Patsy's disappearance. Norman voices his refusal at first, but they tell him they have a warrant. In addition, they cite that a lot has happened in recent weeks in terms of disappearances associated with the Bates' Motel. Norman rushes upstairs to mother's room to remove her so the police don't find her body. He is startled to discover that she is not there. Norman keeps her in the chair and the fact that she's gone is cause for panic.

Tracy Venable talks to Maureen and tells her about who Norman is, what he did and how he has been committed for the past few decades on and off. Her goal is to warn Maureen and convince her to get away from him. She leaves the motel to stay with a priest. In the meantime Tracy reaches out to the diner's owner again and asks him about Mrs. Spool. He tells her that the diner used to be owned by Harvey Leach. Immediately, Tracy goes to the nursing home where Harvey Leach is now residing. Though he is confused and elderly, he tells Tracy that Mrs. Spool was formerly in an institution and killed her husband. Tracy later investigates and finds a newspaper from Fairvale that reports on "Sister Arrested in Bates Murder-Kidnapping" headline. She finds out that Norman was a kidnapped baby; Mrs. Spool took him from his biological mother due to jealousy. She loved the father and believed that Norman should have been hers

with the man she loved.

> *"It's his unwillingness to just give in and say, `Oh what the heck, I'm just going to be a bad guy.' You're not rooting for his failings; you are rooting for his good side."*

<div align="right">Anthony Perkins</div>

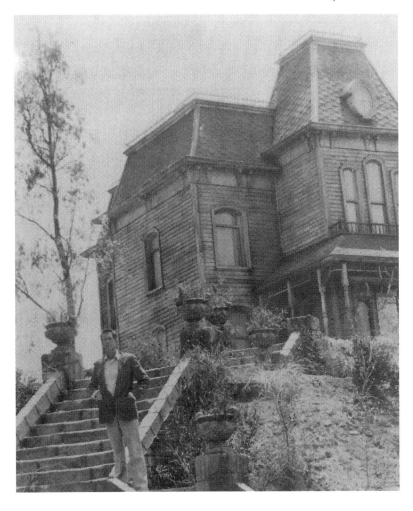

Norman then goes on a search to find mother. A note is found telling him that she is in Room #12. He finds out that Duke took mother's body and now wants a ransom for its return. Duke tells him about how he needs money and this is his one way to get it. He is adamant about getting paid to bring mother back. The two get into a physical fight and Norman ends up hitting Duke over the head with a guitar. He then takes both Patsy's and Duke's bodies to the lake where he plans on driving the car with their bodies into the swamp. At the lake, Duke regains consciousness and he and Norman get into another fight. He jumps up from the back seat and tries to strangle Norman. Eventually though, Norman wins out and Duke drowns in the vehicle.

Maureen, though she was concerned about Norman when hearing of his crimes and mental state, convinces herself that he is her true love. Scarwid, as Maureen, plays a delusional suicidal nun to perfection. She tells the priest that she not only sees Norman as the perfect companion, but she has been seeing Mother Mary in visions since her first few days at the motel. Though he questions her actions, she leaves to go find her true love back at the Bates' Motel.

Upon arrival at the hotel, she rushes up the stairs to find Norman. She tells him that she knows he is a murderer, but she also knows that he saved her life. Despite all he has done, she is willing to overlook it and see the good in him, because she knows it is there. He shows himself at the top of the stairs and is enamored with her words. He has been trying to change his image and find someone who sees more than a murderer for many years. As he shows himself from the shadows, he is covered in mud due to taking the two bodies to the swamp. She romantically tells Norman that she slipped too and they grab hands. Just then Norman hears mother yelling from the bedroom. "Norman" is all she yells but he turns around to the room and lets go of Maureen's hands. She falls backwards down the stairs, only to be impaled on an iron stake. Norman screams "Mother!" He

later tells her that he'll "get" her for this. She tells him he "doesn't have the guts".

Tracy returns to the Bates' home to find Maureen and protect her. After inspecting the taxidermy room and looking around the house, instead, she finds Maureen's dead body. It is set up on the couch as if in a shrine, with candles lit all around her. She turns around and sees Norman dressed as mother, talking in a woman's voice. She rushes up the stairs and tells Norman that Mrs. Spool wasn't his mother. Rather, she was his aunt and she kidnapped him when he was a baby. Norman continues to rush towards Tracy and hides from her. She doesn't know where he is and finds Mrs. Spool's corpse sitting in the bedroom. Norman raises a knife to but ends up stabbing the corpse of mother instead. He yells "So I don't have the guts, huh?"

In the final scene, Sheriff Hunt is shown taking Norman hand-cuffed to the squad car. He tells Norman that he may never leave again. Norman responds with "But I will finally be free." In the quad car however, he pulls out Mrs. Spool's severed hand—the one he was stitching at the beginning—and stares eerily into the camera with a half-grin in the way only Norman can.

> "You can't get rid of me!"
>
> Norma Bates

The Unique Story Elements

Within *Psycho III* there are some consistencies that play perfectly to the mythology of Norman Bates. He is still a serial killer. He is still hearing from mother. He is still at the Bates Motel and lives at the Bates' house. Tangible things within the script are maintained to keep the seamlessness of the storylines. In addition to those though, the story also has other consistencies. Norman is still coming out of an institution and trying to find his sanity. He's been in therapy

for years now and the audience wants to know, yet again, if this time Norman has found a way to conquer his demons. Has he been able to rid himself of mother and separate himself from her maniacal influence and control?

The core of the story is what people love. They are tied to the basics. Still, with *Psycho III* there are some new elements introduced too. A lot of the story is tongue in cheek. You get the idea of that from the first few moments when the suicidal nun gets to the hotel and sees dead birds, to Norman sitting in the car at the end, you get a sense of the irony of the story immediately. Setting the tone is that bird scene. As Maureen, the nun, walks up to the motel she sees a bird feeder and birds have fallen to the ground underneath it. The camera pans to the birds. This is an obvious nod to "The Birds" movie and brings it into the new film.

Another fun scene is at the beginning also when Norman is seen relaxing in his taxidermist office working on sewing up birds. Just when you think that he has found a unique, and legal, hobby, the camera shows him working on stitching a human hand. This is another tell-tale sign that Norman may not be as adjusted and normal as hoped.

The repeated visit to small confined spaces for murder is also rife throughout the film. One is when Norman, dressed as mother, goes to Maureen's room with the intention to kill her. He is dressed as mother—in a dress and wig—and brandishing a butcher knife. He walks into her bathroom, ready to kill her when he suddenly pulls the shower curtain aside. As he does this, he sees her lying in the tub with slit wrists. This is reminiscent of Norman's kill in the infamous shower scene. As a unique add-on though, the writer stopped Norman from murder, but still filled the tub with blood and gore. The second location for confined kills where Norman does go through with it, is when he kills a girl in a phone booth.

The very fact that Maureen is a former nun is also a unique twist to the story. She represents purity within the movie but is questioning it. She is another character caught in the emotional drama of good and bad, just like Norman. She accentuates his struggle, but in a different way. While Norman is struggling with good (himself) and bad (mother), she is struggling with good (being a nun) and bad (suicide). The fact that they come together and are attracted to each other is a great way to convey to the audience that the two are "made" for a partnership.

The unique story that develops for this iteration of Norman's story is another element that makes it a film worth seeing. The movie presents even more of the story of Norman Bates and lets the viewer see what he does while trying to get his life together… again.

Soundtrack Music and Song Release

One of the most important aspects of the movie is its soundtrack. If you listen carefully, you can tell immediately how it is used to supplement the storyline. In movies like this one, the music is not just a background player; rather, it is accentuate the tone and vibe of the dialogue and actor's point of view. Consider Alfred Hitchcock's use of sound during iconic scenes from *The Birds*. It is the sharp and almost annoying string-instrument tones that really put the viewer on edge.

When reviewing the various iterations of the *Psycho* presentations, music was always a hearty element. Recall that Hitchcock even said that he believed his film would not have been half as compelling had composer Bernard Herrmann not taken the reins at creating a soundtrack that worked for the picture. His choice of strings was actually one based on circumstance, rather than first choice. The film was tight on budget so Herrmann opted to cut costs by using a string ensemble rather than full orchestra. This choice

turned out to be serendipitous for this movie and the generations to come.

In *Psycho III* music is important and created by Carter Burwell. Burwell started his career as a composer working closely with the Coen Brothers. They had a slew of films out and each one required an intense and appropriate soundtrack. These directors are known for their intense attention to detail, so Burwell had to be specific about his sounds and aural tools used. He created a full soundtrack to the movie with a special song released for it titled "Scream of Love" as sung by Stanton Miranda. The song also came out in a few different remix versions and on vinyl. It played on MTV in the late 80s and did relatively well as a dance song.

Beyond the song though, there are a wide range of strange sounds used throughout the soundtrack. For example, when Norman finds the second victim of the story, you can hear a light knocking in the background with a long tone. You also can hear bird's winds flapping in the background. It is small contributions like this that make the film what it is. All elements of the film work together to build a specific emotion within the picture. It is a technique that likely would make Hitchcock proud if he were alive today. These sounds come together to tell the viewers exactly what to expect and they build the anticipation within them. Burwell was able to build a great soundtrack that plays perfectly to a new psychological, horror film entering the new movie market.

Initial Film Release

The movie was released on July 4th, 1986, exactly one year and four days short to the day that the movie started principle photography. It came to the market with a $3.2-million revenue on its opening weekend. Throughout its entire run, it earned roughly $14.5-million. Though it wasn't

as lucrative as earlier works on the Psycho franchise, it still was a sign of how popular the theme still was. Consider that the story of Norman, at that time, had already been going on for more than 25-years. How many films have stories that can boast still being a public draw after that much time has passed? It likely is a sign to the many people who shaped the story over the years.

> *"The second one ends with Norman supposedly rehabilitated, so we thought it lent itself perfectly to going on to a third. But if `Psycho II' hadn't been successful, there never would have been a third. Sequels depend entirely on whether people want to see more."*

Producer Hilton A. Green

It all, of course, began with Alfred Hitchcock, the iconic director who first saw the value of the story. Though there were many other project available to the director at the time, he opted to focus on Norman's. What made this film special was the theme and the horror draw. Horror fans everywhere loved the chilling backstory that was somewhat rooted in truth, though not directly. If you recall Ed Gein, real-life serial killer, and editor of a horror magazine Calvin Beck, who had a domineering and intrusive mother. Put together this made perfect fodder for movie goers everywhere. Another draw was the burgeoning horror genre of the time.

In the 80s, people were used to horror films already, but they hadn't yet grown accustomed to the combination of horror and psychological terror. It is like a group of people who love roller coasters, but have been on all the ones currently built. If a new one is built that has more 360-degree turns than others, they are naturally going to flock to it to see if the adrenaline rush is really worth it. That is exactly what happened with *Psycho III*. People were ready to be pushed to the next level of horror. They knew the

backstory, but getting a new vision into Norman's life and mentality were just too tempting to pass up.

Another element of the draw of *Psycho III* was Anthony Perkins. Having portrayed Norman for over 25-years, he was the expert. He knew the small nuances of the character and was famously adamant about everyone involved with the film staying "real". He had many heated arguments with people on set, noting if a scene wasn't what he though it should be. Other actors would tell tales of how Perkins would spend hours engaged in protracted conversations about what Norman would, and wouldn't do. Perhaps it was his quarter-a-decade tie to this one character that made him so determined to do justice to Norman. Regardless, the audiences sensed his allegiance to the character and responded with continued interest in what Norman's life had evolved into at various stages.

Finally, a large draw for the movie was the fact that it was directed by Anthony Perkins himself. Having gained much respect and admiration for portraying the character for so long, Perkins was the ideal person to direct the film. You can see his innate abilities with film as you watch *Psycho III*. One stand-out scene is the one where Norman puts a body into the ice cooler while the sheriff shows up to investigate another missing person. The sheriff reaches into the ice cooler, pulls out some ice and eats it. As he does, the camera pans down to a barely-seen hand under the ice and ed blood on some of the ice directly next to the ice he grabs.

One thing you'll notice with this film is Perkins showing off his sense of humor. For example, in one scene he is pulling a dead body out of his vehicle. He, as Norman, strains and strains to get the body out and when he can't the audience hears one large "snap" of a broken bone. Since the entire scene is quiet, it is a fun made-you-jump moment that Perkins worked into the story.

Another scene that stands out is the one where Norman, or "mother", kills a woman in a small confined space with the same choppy frames and sounds used in other iterations of film. Namely, when the nurse Maureen tries to commit suicide, the scene harkens to the original one. It is equally as unsettling to see her sitting in a bathtub of blood as it was to see Janet Leigh murdered in the shower. Perkins chose to remind viewers of Norman's past throughout this film, and it is a sign that they should continue to respect his entire history as it built his story today.

The Reviews

When the movie was released, it was anticipated for two reasons:

1. The story. No one can discount the excitement and anticipation of a new story to the Psycho saga. *Psycho III* was no exception. The bottom line is that people love the story of Norman Bates. He may have been the first serial killer to be described as "charming". One of the key elements of his persona was Perkins' intent stare directly into the camera with a half-smile, half-snicker. It was telling of the character because it gave audiences a sign of something truly unique. The smile given isn't ominous, nor is it overtly dangerous or frightful. Rather, it tells the audience that Norman isn't really that intimidating BUT then you see what he does and move through life with him. You see his kills and his violence, along with his mental illness, and you know that there is something much more compelling to the character than your average everyday murderer.

The other element of the story is the possibility that "mother did it". Now the audience knows mother is not real. She has been long-dead. But the movie is played in such a way that Norman does not believe she's dead. To him, she's a living, breathing and domineering character that continues to

plague him. If someone believes so genuinely in mother and her presence, why shouldn't the audience? Perkins sells it so well with his mannerisms and actions, that most of the audience is ready to believe that mother is there and she is really pushing his buttons.

When the buzz of a new chapter in Norman's life is heard, most people love the idea. They are invested in his life and want to know if Norman has finally worked his life out. He's been institutionalized numerous times and has spent collectively years in therapy. It had to do some good, right? Most fans want to visit with Norman and see if he is changing. Has he evolved? Has he gotten anything positive out of the hours of therapy he's gone through? Of course with *Psycho III* Norman tells us that therapy hasn't really don't all that much for him. In fact, he still has mother upstairs dressed and sitting in a chair. And yes- she is still actually a corpse.

Despite fans knowing a little about what to expect, they still get excited about a new movie coming out. This is one of the most telling signs of a story that is able to create anticipation. This is great news for the studio and the people involved with the project.

2. Anthony Perkins' directorial debut. This was a major draw for the viewing public. The truth is that there already exists a mythology on the story. Norman Bates is one of the most recognizable names in the horror world and within the psychological thriller genre. Perkins has created that buzz by putting himself not just into the character's shoes, but also making well-thought-out decisions in terms of how his character is portrayed. All of the small nuances and mannerisms of the character are created by Perkins. Having this kind of dedication and tie to the character is unique in Hollywood. Normally an actor plays a character for 3-6 months and then moves on. Perkins had been tied to Norman for more than 25-years when *Psycho III* came out.

That warrants a special kind of reception by the audience.

The fact that Universal Studios was behind Perkins from the start also is a key to the buzz about the movie. Because they had Perkins as not only the star, but now as the director, the studio put a lot of support into promotion of the film. They also paid a highly-skilled writer to come up with the newest script. Overall, they were able to push the film from the beginning due to the amount of internal enthusiasm.

Creating buzz for a film is critical now and it was the same in the 80s. *Psycho III* benefitted from the anticipation and opened strongly at the box office. Though it didn't do as well as other iterations over the years, it still played well and showed that people were ready for Norman's newest story.

In the end it was a movie that took the story of Norman Bates to new levels. It showed more insight into the famed serial killer's life and history. He was once again trying to maintain some semblance of normalcy in his life, but plagued by mother who just wouldn't leave him alone. In fact, she reminds him early on in her unique cackle that she will "never leave". Hopefully, she never will. Though it would be the next installment of the infamous franchise where audiences would finally get to meet "mother" herself...

Psycho iV

Carrying on the iconic "Psycho" series was the 1990 made-for-TV film *Psycho IV: The Beginning*. It added to the psychological horror film genre and contributed another chapter in the world of the mother-obsessed killer. Of course Norman Bates is back as the anti-hero, but not just portrayed by Anthony Perkins, though Perkins does explore new depths of the character that most protagonists within the genre do not possess. Here is the story of how the TV movie came to the screen.

The Origin of The Story

The origin of *Psycho IV: The Beginning* television movie is rich. Originally, the picture was pitched by Perkins himself not long after the release of *Psycho III* and it may have been inspired by Universal's annual Halloween Horror Nights. Shortly around the time of their first Halloween event in 1986 Perkins and screenwriter Pogue pitched a film proposal that would see the house and motel turned into a full-time Halloween type attraction whilst Norman is institutionalized. Norman then escapes from the hospital with a mute patient and enters the house of horrors. Citing Hitchcock's must earlier remark that the original was meant to be more a black comedy, they proposed that this could have vast comedic sections with black humor peppered in.

Universal passed on the idea. It was rumored that decision was made to pass because *Psycho III* was not very commercially successful and that at the time a staff member of the Halloween event tragically died due to an accident with one of the trams. In 1990, whether this was connected or not, Bloch would release *Psycho House* a novel set in the same Bates house now turned into a tourist attraction.

It was four years later before the idea came back around and the decision was made to make a new addition to the franchise but with a new script. The TV movie was released in 1990 and by that time, Norman had more than thirty years of history behind him. The interesting thing about this addition is that it carries on the story from both Norman's beginning life to his post-life after being released from an institution. In that sense, it can be thought of as both a prequel and a sequel. It is interesting to get a vision into Norman's early years and see him interact as a child and teenager with his mother.

The film was directed by Mick Garris. Garris is known for working in the horror genre with notable film titles such as *Critters 2: The Main Course, The Stand, and Desperation* under his belt. What truly put him in the running as the right person for this job however, was his dual interest and expertise with horror and television. Post *Psycho IV* he moved on to create *Masters of Horror* for Showtime and *Fear Itself* for NBC. A year later, he would host the re-release of classics *The Serpent and The Rainbow* and *The People Under the Stairs.*

The reason Garris was so good at his directorial tasks for *Psycho IV* was because he was a storyteller who knew the genre of horror to an excellent degree. The truth is that a director will make much different choices with camera, camera angles, shots, frames, sound, etc. depending on the genre he or she is working with. Garris had a penchant for horror and he pulled out all the stops for Norman Bates'

story. You can see the great lengths with the ending fire scene where the Bates' house is overcome with flames. The stairway that Norman is on starts to break down, he falls to the ground and the lighting is idea to showcase his fear. Of course his goal is to rid himself of the terrible house and mother, but the symbolism is not lost through camera technique. Viewers are surprised by the amount of realism and care taken to film the difficult scene.

Speaking of the story, the *Psycho IV: The Beginning* story began with an argument. Perkins wanted to do the Universal Studio's production, but wanted director Noel Black to take the reins. Black had worked with Perkins before on the film *Pretty Poison* in the late 60s. The movie was considered to be one of the psychological thrillers of the time and though it got relatively good reviews, was not the box office hit anticipated. Still what it did do was push Perkins into his role as a horror expert and adept at portraying himself within the films, beyond the one-note murderer. Perkins, if anything, insisted that his character and that those working on his films understood the impetus of the characters on a much deeper level than just the lines or the main storylines. This is what turned into quite a few arguments for him on set. Perkins teamed up with screenwriter Charles Edward Pogue to formulate a strategy that would encourage the studio to allow Black to direct. He was surprisingly negative about big studios however—a fact that probably likened him to Perkins. Perkins was known to "think outside the box" and Pogue had just the reputation of considering studios intrusive enough to the storyline, to ingratiate him to the actor. Perkins was known also at the time for his in depth desire to get to the core of the character and portray that completely to the audience. They likely bonded over their ardent dedication to complete character development. Pogue stated that he believed that the studios "ruined" his screenplays for both *Kull the Conquerer* and *Dragonheart*. He also was a well-versed thespian himself who worked with such big-name stars as Charlton Heston. With that pedigree, he and Perkins got along famously well and together they wanted to take on Universal Studios to get Black and the movie made the way they wanted.

Although Perkins and Pogue banded together to make a serious play for Black to direct, in the end the studio refused. Unfortunately, the movies that they relied his argument on were considered to be both financial and critical failures.

Because of this, the studio insisted on bringing in Mick Garris. As stated earlier, Garris already had a good history with horror and he was adept at translating the script to television. From there, Joseph Stefano was tagged in to create the script. Stefano was known in Hollywood as an expert writer of horror having worked on the 1960 *Psycho*, *The Outer Limits,* a horror like episode for *Star Trek The Next Generation* and *Eye of the Cat*. He also worked with and for Alfred Hitchcock so he understood the underlying mentality of Norman already. Universal Studio executives believed he had what it took to make a profitable story for the character.

If anything, Stefano made an important decision early on that would shape the storyline. He decided that this film would have to stand on its own, with no real connection to any early adaptations beyond the given backdrop of Norman's first story thirty years prior. Stefano recognized much of the middle information as worthy of no mention because it didn't do anything for the story. Rather, he came up with the background for Norman himself—giving him a childhood that the viewers were drawn into. This also opened the door for an oedipal complex to be examined. Of course everyone already knew that Norman was always focused on mother. He wanted to please her and be the "man" of the house, but Stefano got the opportunity to dictate how far. He had the chance to explore the issue because of the scenes showcasing Norman as both a young boy and a teenager.

Another decision that Stefano made to shape the story of *Psycho IV: The Beginning* was to bring in young actress Olivia Hussey as the role of "Mother". This definitely added to the story because as far as the audience was aware, mother was either an elderly woman in very dour clothing, or a corpse. Most of the fashion choices within the film were of heavy Victorian-style dresses with up-to-the-neck cuts and sleeves to the wrists. Her wigs were equally as conservative

and out-of-date. In fact, mother was like something painted from a historic novel—not much for the audience to relate to. What Stefano recognized was that the audience had a great disconnect with mother. Yes, they had heard about her and what she did to Norman, along with their misguided relationship, but they never got a chance to see who she was. Norman had that opportunity and now it was mother's turn.

The other interesting thing about the story is the title's byline "The Beginning". Stefano truly created a beginning for Norman in two ways. First, he created the childhood of Norman. He carefully drafted a childhood filled with emotional and bullying abuse. Mother was overbearing and demeaning to her son and that is what contributed to his ending situation. Viewers also get a picture of a very young Norman who at the age of six had to attend his father's funeral. In this setting, he also is the victim of abuse when he innocently giggles in his seat. In one sense, this is the beginning that the title is planning on showing the viewer, but there is a secondary reason. Secondly, "The Beginning" refers to the future. Norman is seeking closure- he makes that clear from the opening scenes when he calls into the talk show of Fran Ambrose. He wants a definitive end to his demons. Though he believes the end to be one thing, it turns out to be another. The other unanticipated end signifies a new beginning for Norman as an adult, expecting a new baby with his wife. This is their beginning. The dual "beginnings" make the story truly a beginning on multiple levels. It was this story that Stefano played with and wrote to be complete—ushering in some peace for Norman…finally.

In this iteration, Stefano also wanted to paint mother as a sweet, attractive character in her younger years. He wanted to create her story. Sticking to the one-sided view of her as an "old battle axe" wasn't enough for a story of this depth. It was time to bring mother into the picture and give audiences a reason why Norman would care so intensely

132

about mother and why they should care for her. It gave the screenwriter more creative license also. Norman has been written about thoroughly—he has been explored on many levels thanks to previous screenwriters and to the actor Perkin's portrayal. A new writer needed extra material to develop and allow to flow. This is where mother was the ideal fit.

The key to her success though was to marry the storyline of mother to the right actress to portray her. By introducing Hussey as the mother, Stefano started to give the audience a reason why Norman may have been obsessed with her. She wasn't a horrifying old woman who screeched orders and insults; rather, she had her good side that was truly "motherly" and kind at moments. The dynamic of mother and Norman was further painted when Stefano created Norman as a young boy and teenager. Again- the audience is given a vision of who he was growing up, before he had the chance to fall into full adult madness. He was a child who wanted to please his parents, in this case a single mother raising him alone. Of course it opened the door to an oedipal complex that was longstanding throughout his life. This of course is the sexual desire of a son as focused on his mother.

Stefano made a pointed reach to Norman's childhood and this was intended to give the audience the chance to understand him and empathize with him even more. Combined with Perkins' portrayal, viewers could not help but walk away from the film with a new insight into who Norman was and why he did what he did. Henry Thomas was cast as Norman as a teenager. Thomas of course already had a successful career going, having starred in "E.T. the Extra-Terrestrial", "Cloak & Dagger" and "Murder One". He was able to carry on the Norman character with the boy-next-door looks and innocence that were completely contradictory to a murderer. It was part of the ongoing dichotomy of the storyline. Killers, after all, are supposed to

be ugly, angry, loud and obvious, right?

The Psycho story was one of the first to challenge the theory of a killer "looking" like the bad guy. It introduced the idea of a cold-blooded killer living amongst normal people. That killer could be the boy next door, or it could be your mailman. It could be your local librarian or your introverted neighbor. Again—audiences loved the new thought and loved to be frightened. They made it clear that Norman was just the killer they wanted. After all, he was a very young boy who had terrible things heaped upon him-psychological things- that surely made him a victim too. Could you really hold him responsible for his actions when he had so much mental and emotional pressure coming from the one person who was supposed to love him most? What else was he to do but assume mother's persona and kill in her name?

Cast

The cast of characters for the TV movie was created to bring more depth to the character Norman Bates and his origins. Olivia Hussey was already on board to portray mother in flashback appearances. Her job was to not only act like a mad woman, but to bring a likeability to her that was not formerly mentioned. Combining her with Henry Thomas as a young Norman, also brought more complexity to the story. You can see how young Norman is confused by mother-one moment she is happy and the next moment she is in a rage over something as normal as his like of a teenage girl. Had mother been portrayed as merely an old domineering figure, who would continue to like the story? Who would continue to develop empathy for Norman and the storyline as a whole? After all, Norman came from his parents. With his father out of the picture, having passed away when Norman was 6-years old, that left mother to tell the back-story.

One thing that was discussed by Thomas was the lack of support he felt though from Perkins. The two were portraying the same character, but in different decades. Thomas stated in a documentary that he would have liked more support from the famed actor. Perkins helmed the character of Norman for thirty years when Thomas stepped into the mix. He looked to the older actor as one to give him some direction, or insight. Instead, Thomas claimed, Perkins only offered him general ideas about the character and told him to stay true to who Norman was. Possibly it was akin to being a novice and discussing the topic of specialty with a professional. They consider the small nuances to be obvious. This made it difficult for Thomas to bond with Perkins, the former stated. In the end though, they had no on-screen time together so it worked out.

Beyond the main characters, CCH Pounder was brought in to portray the radio talk-show host who speaks to Norman as "Ed". Warren Frost portrays Dr. Leo Richmond, the psychiatrist who first interviewed Norman when he was arrested at the Bates Motel for murder thirty years prior. Bit characters rounded out the cast, but the main ones contributed to the storyline of Norman for "Psycho IV- The Beginning".

Production

Universal Studios realized early on that Norman Bates would continue in the movie world as one of the most important serial killers portrayed. Whether it was his boy-next-door looks, Perkins' masterful portrayal of the character or his depth of content to work with, no one could exactly pinpoint. In the end, it wasn't important though. What they did know was that audiences wanted to know more about the character. His plot was so interesting that they wanted to know who Norman was and why they still, despite what he'd done and continued to do, empathized with him. It is a storyline that Hollywood began to toy with: the killer who isn't just one-sided. No longer were murderers merely dark figures in the shadows who were for the most part cast aside and loners. They weren't the "lone wolves" of society that if not carefully watched, would surely take victims one by one. Rather, the murderers were the most innocent and unassuming among the crowd. They were the ones who were living in plain sight, blending in with the general public.

This idea of having a "killer next door" made for fantastic film making and Universal Studio executives were thoroughly aware of this. They pushed for a new movie to be made. Part of the reason for the push also was because since the 60s, the Norman Bates house and the Bates Motel were both staples on the Universal Tours. Though the movie was decades prior, the tours never lacked in visitors wanting

to hear and see "Norman". In fact, when visitors riding the tram caught sight of the house they were treated to Norman coming out of the hotel with a body. He slides the body into the trunk of a waiting vehicle and then stares eerily at the viewers on the bus. People repeatedly love the thrill of seeing him stare at them intensely and it usually makes for a few cheers and shouts. Then, he starts moving towards the bus and soon reveals a knife in his hand. As he starts walking faster and faster, the tour bus pulls away with the guide usually feigning fear to play along with the attraction.

Because of its popularity, Universal Studios executives did not want to close the now highly popular part of their tour. The *Psycho IV: The Beginning* project was instead moved and shot entirely on the Orlando Florida Universal lot. For almost one full month starting in June of 1990, filming took place. Both the Bates' house and the Bates Motel were re-created at the park, with the façade only. Many people mistakenly believed they could actually walk inside the house and motel. This was not possible since the actual interior had never been built beyond a soundstage. Initially the plan was to film the made-for-television movie prior to the park's opening day, in the end the movie had a few delays that made that timeline impossible. Instead, parts of it were filmed while the park was already opened. A happy result was that visitors were able to watch filming of parts of the movie, creating the high-profile visitor-satisfying attraction the studio desired.

During production there was some controversy and issues to get over though. They both involved the film's star Anthony Perkins. He was in his late fifties when the film went into production and unflinchingly intent on bringing Norman to the screen in a very specific way. He demanded that others see the same vision and carry it out. For example, there were numerous times when he spoke with director Garris requesting a long protracted conversation about a specific scene, line or even direction of the entire film. It slowed

production—not to the point of the studio stepping in, but to changing the timeline and benchmarks for release. His demand for the characters and the story to remain "real" were never ending. Garris reflected later that in retrospect, he was appreciative for Perkins' passion about his character and insistence. Though at the time, it wasn't as enjoyable, in the end he was grateful for the discussions. Creative control can be a harrowing issue with actors—particularly those like Perkins who know the character better than anyone else and have portrayed him numerous times—and directors. One thing Garris added though was that Perkins was almost demanding and forceful about his ideas and making sure they were heard. He was even heard describing Perkins as "bullying" in some of his delivery of ideas and thoughts. The saving grace however, was how receptive the actor was to the passionate input of others. If he could sense a true desire to stay true to the story and true to Norman, he would accept challenges of thought.

In the end though, Perkins always referred to Garris as a great director. Though they butted heads more than a few times on creative differences, they were both committed to telling the best story possible. Perkins from a more personal point of view and Garris from a more big-picture vantage point. Though they had to overcome some intense discussions, in the end, they were both fighting for the same thing, which both realized. They wanted the best portrayal of Norman Bates and the story of Psycho possible for the screen. They wanted to give viewers a new picture into the world of a multi-dimensional serial killer who is the way he was because of many different influences. There no longer was a temptation to rely merely on the good-bad, either-or storyline of olden times. The moviegoers of the day were much more sophisticated in horror. They wanted more than just one or two frights here and there throughout the story. Rather, they were waiting for something that truly drew them in and created an emotional drama within them. what better

way than to capitalize on Norman's intricacies and mental complexity.

What was always a constant, may have been a double-edged sword: Perkins' tie to Norman. When an actor normally portrays a part, they do so for one to four months. In that time they are expected to understand and reflect the character's thought and action. They convey those things to the audience through the medium and then move on to another project. Perkins was in a unique situation though in that he was tied to his character from *Psycho* for more than thirty years. It gave him much more time to understand the character and formulate a "bond" with the fictional Norman. Likely this is why he fought so hard for Norman to be heard and understood. Inevitably there was some in depth empathy and connection that no one but Perkins appreciated. It was this that pushed him to fight so hard for the killer's story to be told properly.

In an interview Perkins once described the character of Norman as the very thing that kept him working for many years—gave him an actor's much-desired longevity. On the flip-side however, it also possibly typecast him and kept him from other roles. Though he admitted there may have been a downside, it was never something he committed to. Rather, he stated until the end that the character is definitely something he would do if given the chance to go back and choose again. He cites "getting the call" from great director Alfred Hitchcock to first take on the role of Norman back in 1960 and how it truly changed his life.

The other issue that affected the filming and production was a real-life situation. Anthony Perkins was diagnosed with HIV at the time and much of his treatment had to be scheduled around filming. Of course the crew and staff were supportive, but that is another issue that pushed its timeline back a few weeks. At the time in the early 90s treatment for the condition was much more limited than it is now and this

definitely affected the movie.

Plot

The story takes place after the main character, Norman Bates, is released from a mental institution. He has had a lot of history with being institutionalized, but a judge in his case is convinced that this time, he is ready to assimilate back into normal life. Of course he was released previously, but failed to turn his life around and ended up at the same place- a mental institution. When the story picks up, he is married to Connie, a psychiatrist who is also pregnant with their first child. Norman is worried however that his child will inherit his mental issues so he is intent on finding an answer to his own mental state, and putting an end to it.

One night a popular talk show host named Fran Ambrose is speaking on-air with one of Norman's former treatment specialists, Dr. Richmond. The two are discussing the issue of a child murdering his or her mother, or matricide. The issue dates back in history from 284 BC and even Cleopatra III was killed by her son according to history. They topic of the night is the mental state of this type of murder and the on-air hosts start to move forward in history, dissecting the mentality of the murderer. Norman listens to the show and decides to call in, but he uses the pseudonym "Ed" when he gets on the air.

Norman, or "Ed" (a nod to Ed Gein no doubt), relays his loyalty to the program and starts to mock Dr. Richmond and his credentials. Of course his take is that while the doctor shows no real insight into the issue, Ed knows first-hand the inside view of the mental illness that causes a child to murder their mother. Realizing that the caller is not merely a random one with a general question, they ask if he has ever murdered. Ed turns to camera and clearly stated into the phone that he has killed before and is "going to have to do it again".

The radio host starts to ask pointed questions about murders, thinking at first that he is a deranged caller who is bluffing. Ed tells Fran that he killed a girl who had a crush on him when he was very young. In flashback form, the film takes the viewer to a very young Norman Bates and a young teenage girl who wants to visit him. Of course, Norman knew his mother would never approve, so he at first tries to dissuade the girl, but loses. She enters his room and starts flirting. Norman claims to hear a noise and goes to check it out. The viewer sees mother lying in bed, back to camera, and telling Norman to kill the girl, who she refers to as "a whore". Norman refuses and mother tells him that she'll do it herself.

The camera cuts to Norman taking mother's wig and a dress from her wardrobe. The teenage girl comes looking for Norman and wanders into mother's room. As she looks at a figure in bed, she realizes that mother is actually a corpse. As she screams, Norman, dressed in a wig and a woman's dress, steps out of the shadows with a butcher knife and kills the girl. The interesting thing about the scene is that it is reminiscent frame for frame of the first infamous "shower scene" from 1960. The blood splatter, the screaming woman, the sharp knife stabs and the screeching music all play together to create the same terror and psychological tension of the Norman Bates' story. Post-murder, Norman starts crying out to mother in horror when he realizes there is blood everywhere. The radio host Fran asks Ed if this was his first time he had "a conversation with a corpse". Ed stated that he started talking to mother right after he murdered her. Dr. Richmond asks where Ed lived at the time, but Norman panics and hangs up quickly.

Later, Norman puts the radio back on and heard Fran imploring Ed to call back. She stated that he understands the issue first-hand so they would like to talk to him further. Norman, as Ed, calls back in and starts defending his mother stating she was merely a "product of her time". Dr.

Richmond notes how the caller is quick to defend the woman he killed. Fran takes the route of trying to find out the impetus for the murder. Did mother smother Ed? Was she overbearing? Was she controlling? Ed states none were the case, rather, he was just leery of mother's inconsistent moods and behaviors. Ed tells the radio hosts that his father died when Ed was just 6-years-old and then retells the tale of his funeral. He puts himself there as both a child, and an adult.

The producer of the radio show warns Fran to keep Ed talking. She asks him to tell them 15 things about his mother. Soft music plays as he retells the list of things about her. He romanticizes her as a beautiful, happy and loving woman who doted on him. He mentions how mother was able to make him "feel big". Fran gives other listeners a short synopsis of Ed's story and he interjects by telling her that he killed mother's boyfriend also. Dr. Richmond and Fran take note as Ed tells them the story. He starts off with validating himself as the "man of the house", running both it and the Bates Motel. He claims that his mother's boyfriend was unnecessary and that's why he killed him.

With another flashback, Ed tells the story of how his mother found pornography in his bedroom when he was a teenager. She makes him throw it out but when he has to go out in the rain to dispose of it, she follows him with a raincoat. Dr. Richmond interjects and notes how Ed portrays abuse as fine as long as it is just between him and mother. According to the doctor, it was the third party that irked Ed to discomfort. Ed accuses the doctor of trying to turn the story into something lewd. He also tells them about his other kills. Despite bringing it up though, he quickly returns to mother. He tells a story of how mother dressed him as a girl and referred to him as "Norma". She locked him in a closet to think about his condition. Ed starts hallucinating while on the phone with Fran and Dr. Richmond. He wakes up on the floor as Norman in real-time and tells the talk-show hosts

142

that he tells them he'll be back.

The hosts get together off-air and Dr. Richmond surmises that "Ed" is actually Norman Bates, a patient he treated years prior. Fran believes the story and the other two staffers debate what to do. The doctor is convinced however that he has the means of coaxing the truth out of Ed to get him to admit he is actually Norman. He also reminds the talk-show staff that he was the first doctor to initially talk to Norman after he killed Marion in the shower thirty years prior. In the meantime, Fran tells a staff member to call the city Norman Bates was residing in prior to murder and check the Bates Motel to find out if he still runs it.

When they return to the phone, Dr. Richmond tries to take on Ed. He begins accusing mother of belittling Ed, thus pushing him to a murderous rage. He brings ownership away from Ed and to the beautiful mother he described. Ed denies this quickly and turns to Fran. He makes it clear that he'd like to continue talking but wants only her, rather than the doctor. Fearful of losing the caller, Fran starts to engage Ed. Ed tells them about mother's words- calling him useless and demeaning him as a child. Though Fran tries to empathize, Ed backtracks, telling her how "remarkable" his mother actually was.

They take another break and the doctor warns against engaging Ed any more without tracing the call and alerting authorities. He believes that Norman, who is posing as Ed, will kill again if the talk show staff doesn't act quickly. The staffer returns after researching Norman and says that he left his home town "years ago" and the motel is ready to be demolished. Fran and the doctor get into a heated argument- she wants to talk to Ed as a normal person since psychiatric treatment didn't help him. The doctor ends up leaving to catch a plane.

When Ed returns, Fran Ambrose starts to ask him questions

that may identify him. He complies by offering up some personal information. He discloses that his wife is on her way home from work. Fran asks about where his wife works and he tells her that his wife works at an institution as a psychologist. He also tells her that this is his birthday and they are celebrating. Fran asks about his wife and whether or not Ed treated her. He tells her that his wife actually treated him. He goes on to compliment his wife, citing her caring nature and ability to help people. He continues to share some identifying information but abruptly asks where Dr. Richmond went. Fran tells him that he left and continues to ask about the location where Ed's wife works. He chillingly warns that they should focus on the show. Fran agrees and asks how he killed his mother. With one word, Ed reminds the talk-show host and listeners that he is a killer. He says "slowly".

From here, Fran starts to hone in on what the impetus for Ed to kill his mother. She asks him what drove him to actually do it. In flashback form, Ed begins to tell her about her mother's boyfriend. He is a harsh and arrogant man who Ed spies coming home with mother one night. The two retreat to one of the rooms in the motel and Ed watches them from the window. He creeps down to peek at them through a hole in the wall as covered with a painting. It is here that he sees mother having sexual relations with her boyfriend and is thoroughly disgusted.

The next morning as Ed is getting ready for school, mother is in the kitchen making breakfast. Sensing Ed's discomfort, mother asks him if he saw her and her boyfriend, Chet, the previous night. She also notes that she saw him watching from the window in the house when they returned home. The plan, mother tells Ed, is for the two to get married once Chet gets a divorce. Ed questions where mother "found" Chet and asks why mother is now hanging out at cheap bars. Mother confirms that she did meet Chet at a bar and that he is a bartender...or was. She tells Ed the plan of

having Chet work at their motel from now on, which doesn't sit well with Ed. At that point Chet comes down to the kitchen dressed in Ed's father's old robe. He refuses and Ed leaves quickly.

Chet and Ed are then on the Bates' grounds in front of the house boxing. Apparently, Chet is going to teach Ed about how to fight and defend himself. The two start sparring but Ed isn't readily participating. Chet starts taunting Ed, which infuriates him. He tried to take a swing at Chet but misses; Chet ends up hitting him. Mother shows up and the two start laughing at Ed. The film brings the viewer to a present-day Normal who is eating an apple.

From here Fran starts to ask Ed if he is still there. When she gets no response, she goes to a commercial. At this point her assistant runner returns and reports that she is still trying to get information from the police station of Faireville where Norman Bates was raised. Though they answered some questions, they were not divulging any personal information on him. She offers to call the newspaper again to see if she can get some additional information.

Ed calls back in to the show and Fran turns her attention back to him. She asks if he is planning on killing as a result of his mother. Ed tells her that his mother has nothing to do with the kills, or wanting to; however she has always had a "strong effect" on him. He tells her that he doesn't want to be locked away so he hasn't hurt anyone in four years. He inadvertently says that he wants to protect the world from "Norman Bates".

Fran asks why Ed would ruin his new life and lose everything for one more kill. They go back and forth and Fran states that she believes Ed wants her to stop him. Ed dismisses her argument and says that he can merely hang up to end the entire thing. She quickly goes to another caller who asks about Ed's murder of the teenage girl. He refers to

the girl as a "victim" which sends Ed into another flashback. He tells the listeners that his second kill was an older woman.

In the flashback, the viewer sees this older woman in a car with Norman at 2-o'clock in the morning. The two are kissing when Norman remembers he has to give his mother her medication at that time. He states that he'll return shortly, and upon return take the woman somewhere "private". Norman leaves the woman in the vehicle by herself while he goes up to the house. As the woman is putting on lipstick, she hears Norman in the house screaming in an argument with mother. She dismisses it. Seconds later, Norman, dressed as mother appears in the backseat and puts a rope around the woman's neck. He tells her to "drive". The car is seen driving off into the night.

In the next scene, Norman is dragging the woman's body out of the vehicle and putting it into the trunk. Though he believes she is dead, when he drags her to the back of the car she starts screaming and fighting. He grabs the rope and strangles her. He proceeds to put her into the trunk of a car and pushes the car into the lake. As the vehicle is going under, he hears knocking coming from the trunk and was horrified that the woman still wasn't dead. As she is screaming from the trunk, the car drifts completely under water. The last frame of this scene is a teenage Norman dressed in woman's clothing and a wig standing by the lake watching the car go under as the pounding continues.

Fran asks Norma about his plan to kill someone that night. She is trying to still dissuade him from going through with it. She asks Norman if mother made him kill. Norman takes issue with that and makes it clear that mother is not making him do anything. He tells her that mother is dead. He also tells Fran that talking to her has helped him sort through the issue. It hasn't stopped him from wanting to kill again, but it has helped his mental state. He then begins the story of

146

mother's death stating that seeing her in the coffin was the tipping point for him.

Another flashback scene happens where a teenage Norman walks up to the coffin holding his mother. It has been delivered to their home. He opens the coffin and states that he felt a pain he refers to as "soul cancer". He states that at the time he had to get mother "back" by any means possible. He takes her out of her coffin and notes that the "strychnine" caused her hair to fall out and the mortician put a wig on her. He removes the wig and reiterates that he just wanted her back- any way possible. Norman is seen doting over mother's body- he uses his amateur taxidermy skills to sew up her body and keep it. He closes the scene stating that matricide is unbearable and most harrowing to the son who commits it.

Fran returns and implores Norman to not go through with another murder. She asks him to consider how his wife will feel when she has to come to the station and hear about what her husband has done. Or, she offers what if his victim fights back and Norman ends up dead. She also tells him about how much his wife must believe in him—to fall in love with him while he was in an institution. Losing him would be too much to bear for his wife is also what Fran reminds Norman of. He surprises her by telling her that "she" deserves to die. Fran is awestruck when she realizes that Norman plans on killing his wife, Connie. She turns to the show runner and orders her to call the city newspaper again but this time, tell them it is a matter of "life and death". She then turns back to Norman.

She begins to try to talk him out of the killing, asking him why his wife deserves to die. He screams that his wife "allowed herself" to get pregnant. A flash of lightning strikes the screen and thunder crashes when he makes the announcement. Finding out that his wife is pregnant makes Fran even more concerned for the outcome. She asks why

the wife should pay with her life. He tells her that they agreed prior to marriage that they would not have any children. He also admits to killing "damn near a dozen" humans in his past and says that he doesn't want to carry on his lineage. The fear is that he will pass on his condition to his child. He also notes that his wife told him that she stopped taking her birth control without telling him, so that is why he blames her for the pregnancy.

Fran is startled at the new information and questions his wife's intention. Norman tells her that this is where he and his wife differ: his wife believes that his psychosis is not hereditary whereas Norman does. He believes that any child he has will be born with the same mental condition he has and it is the same condition his mother had. He goes on to call his baby "a monster" that he does not want. Fran reiterates that the time is approaching 10pm, which is when her show goes off the air. She asks him to talk to her via cell phone so they can continue their discussion. It is her belief that he doesn't really want to kill his wife, which is why he called in to tell his story. She reminds him that it is not too late to change his mind completely and not go through with the murder. He says that it is because his wife's mind is made up about having the baby. Fran eludes to abortion but Norman tells her that his wife would never do that.

The screen then returns to mother and Chet together in bed, with Norman as a teenager hearing them from the bathroom. He adds strychnine to their pitcher of iced tea and brings it to their room. Chet immediately has some and goes to the shower. Mother also takes a glass. Norman watches nervously from the doorway. Suddenly Chet comes out of the bathroom vomiting and tells mother "it is poisonous". Chet jumps at Norman and starts fighting him. They land on the stairs and he falls down. At the same time, mother comes down following and she also is in a state of shock. They both die at the bottom of the stairs—poisoned by Norman.

[Norma starts to hit Norman]
Young Norman Bates: What's the matter? What did I do?
Norma Bates: Nothing, nothing, nothing!
Young Norman Bates: Then why are you hitting me?
Norma Bates: Who else can I hit?
[gives him the newspaper]
Norma Bates: There not going to build it where the highway is. No, because from there the world would still be able to see us. It's gonna be miles away. Nobody will even know we're here!
Norma Bates: They're putting us out of business. What am I going to do? How will we live? You, you're just like my father. Never a drop of sympathy!
Young Norman Bates: I'm sorry.
Norma Bates: Sorry for what? What the hell good are you if you can't show a little sympathy?
Young Norman Bates: Well, I don't know how.
Norma Bates: No, you just know how to cause trouble. Because of you my bladder's damaged. I can't hold water. That's why I'm always running to the toilet. Did you know that?
Young Norman Bates: Yes, I know.
Norma Bates: I was fine until I gave birth to you. You caused a lot of damage. I should have gotten rid of you the day I found out I was gonna have you. Not one thing you've ever said or done has made all I've gone through with you worthwile! Not one blessed thing! I should have killed you in my womb. You sure as hell tried to kill me getting out of it.

Norman drags mother's body downstairs and suddenly hears her moan. Realizing that she is still alive, he picks her up and puts her in a chair. Her eyes roll to the back of her head and she dies, with Norman watching. Suddenly Chet rushes from behind and grabs Norman with one last try to kill him. He fails. Norman brushes Chet's body off and goes back to

watching mother peacefully sit in the chair he put her in.

After he relays the story of his mother and Chet's poisoning, Fran starts yelling his name. She asks him to stay on the line with her. He tells her that it is the end of the Fran Ambrose program. She tries to keep him on the line, but he disconnects.

Norman as an adult, calls his wife and tells her to meet him at his mother's house. Though she resists at first, noting how "morbid" that is, he reminds her that it is his birthday and tells her to go anyway. Connie arrives at mother's house and Norman is there. He grabs her arm to lead her to the house. They go in and, of course, the thunder outside continues. Connie tells Norman that she is excited about their baby and how strong it will be. He says he won't be able to love the baby and she tells him that he loves her, so why wouldn't he love their child?

He then takes Connie upstairs and pulls out a butcher knife. As he approaches her she realizes what he is going to do. In a moment of hesitation, Norman puts his hand over his eyes. Connie turns and runs. She wanders through the house and Norman follows. He finally finds her and as he is going to kill her, she tells him their baby won't be a killer because she isn't. The very fact that she couldn't abort the baby should tell him that she isn't the same as he is. They hug and Norman instructs her to go wait in the car. He stated that he is going to get rid of the past "for good" and sets the Bates' house on fire.

When he turns around though, he sees mother. He rushes around setting fire to other parts of the house. He then sees Chet, and then mother again. Now the house is almost completely engulfed in flames and he is trapped inside. Connie stands outside in horror, trying to find a way to save

Norman. He sees mother's corpse in her rocking chair and sees her catch on fire. He still manages to crawl out and meet Connie at the front door.

The next scene is daylight and Norman and Connie embrace. He tells her that he is free now and they kiss. Fire trucks are on sight and the house is hollowed out by fire. The two walk away. The final frame however shows mother's rocking chair moving back and forth. The doors shut and you hear mother screaming for Norman to let her out. With that the viewer merely hears mother's last cackles into the camera and the screen goes dark.

Release

Psycho IV: The Beginning was always meant for television. From the hand-picked director who was adept at television filming to the screenwriter who had the same proclivity, the feature was delivered right into viewer's homes. There were a lot of draws thanks to promotions. One was the goal of reaching a new audience that may not have been privy to the story of the Bates' household. Remember that this story had been alive for decades by 1990 when the television film was released. Though there were iconic scenes to remember, not all newer generations knew the history of Norman. In addition to that, Norman's history had not been fully fleshed out either, so this was a great opportunity to give them a voyeuristic view of what it was like to grow up in the Bates' house.

The other draw to the new film was the resurgence of Anthony Perkins. Perkins was a much respected actor since his first days of cinema. In fact, he made his second movie in 1956 *Friendly Persuasion* and received a Golden Globe Award for the New Star of the Year. This was a testament to how good a natural actor he was from the beginning. It was four years later that he would be introduced to Norman Bates—his new vehicle to solidify him as one of the best

actors of his generation. He would later state that the longevity he received as a result of the role was what saved him from fading away as many other actors from the 1950s did.

Another draw was the same one within other iterations of the Bates' story: Anthony Perkin's unique portrayal of a serial killer. Again- he wasn't an ugly or overtly-evil character. Consider the silent films of the early days of cinema. The viewer could easily point out the "bad guy" from his clothing and demeanor well before his actual evil actions were evident. It was a method of drawing a clear line between good versus bad—audiences were not involved in the decision process. Rather, they were clearly told who to root for and who to root against. As cinema evolved though, things changed.

When talkies came about, they maintained the same format-tell the audience who is good and who is bad. There were some directors who early-on challenged that mindset however. Alfred Hitchcock was one of them because he immediately purchased rights to the story of Norman Bates. The draw namely was the lack of black-and-white ingestion the story afforded. The juxtaposed image of a boy-next-door who was responsible if not slightly off-center, against a cold-blooded killer was just too tempting a story to pass up— even for an iconic director. Thankfully the power of Hitchcock at the time was great in Hollywood, so when Perkins got the call that Hitchcock wanted him for the part, he jumped at the opportunity.

The layers of Norman was what made this release so poignant. First there was the question of mother and where she really was. Remember that in the *Psycho VI: The Beginning movie*, the audience can hear mother talking. Of course within the first twenty minutes she is revealed to be dead, but prior to a teenaged Norman's first kill, they still believe that he is talking to mother. Of course something is

"off" about his dialogue with her. She is lying in bed, back facing him and unmoving the entire time—the first clue that mother may not be "watching" as Norman claimed. The entire series of stories are built on that "something off" factor. Even the beautiful Victorian house is not quite right. The question that is posed though is what the audience should do with this added information. If Norman is truly convinced that mother is the one orchestrating the murders, is he really guilty of them? Should he be treated as a guilty party by the audience?

Then there is Norman himself. He was a businessman who successfully ran a motel. He was forced to take responsibility of the house and his business at a very young age. He was by all accounts "the man of the house" well before he was even a "man". The director and actors did an accurate job of creating him as a two-dimensional character. His Dr. Jekyll – Mr. Hyde persona was evident but not merely as a good-bad juxtaposition. Rather, it was a combination of grays that made him so intriguing.

Reviews

When the made-for-television film was released to Showtime on November 10, 1990, it was met with mixed reviews. Technically it was considered a fine contribution to the world of cinema. Its director, Garris, had earned his stripes already and would go on to create many more top-notch horror films and television programs in the future. Still, even he received some mixed reviews with comparisons to the iconic director Alfred Hitchcock. Though they weren't actually warranted due to being completely different projects, in the end, it was an inevitable comparison.

Cult Reviews is a popular website that originated as a magazine. In it there are a group of different reviews on horror films. They initially spoke up about the *Psycho IV:*

The Beginning movie, calling it a film that technically was above average, but lacked in writing skill. Direct-to-video-Connoisseur writers also stated that the story was disjointed, though they appreciated the look into Norman's earlier life.

Many different reviewers held the dual good-bad view of the television film. Some cited the lack of mythology as a problem, while others noted that the script was over-the-top. Of particular note were the scenes between Norman and mother; they were labeled as "difficult to watch" and "highly irreverent". Stefano wrote the picture with a focus on their relationship however- it was his central theme and the only part of the story he could reasonably play with. It was formerly unseen by the audience.

The reviews did little to dissuade the viewing public though. According to Nielsen ratings, the audience measurement was substantial for the film. An estimated 10-million people tuned into the premiere episode. The fact was that despite any challenges with filming or the script, people were still curious about Norman Bates. They wanted to know what he was up to—did he ever resolve his demons? Or, was he still struggling with them? Would he ever have a future after experiencing mother at her domineering best? The story promised to close off loose ends, and that is exactly what people tuned in for. They wanted to see if Norman would continue with killing, or would he ever find some resolution to his story.

Even with the elimination of some of the mythology, audiences bought the new release. They were eager to accept a new configuration of the tale and get to know more about the star. Film Critic Robert Price noted that the television film was incongruent with other iterations, eliminating some formerly-introduced characters who were central to Norman's life. In defense of the film's writer though, it never was intended to carry on any story. Rather, it was meant to give a story that had not yet been told,

which is why Stefano focused on mother as a younger woman and Norman as both a child and teenager.

Two years after its release to television, *Psycho IV: The Beginning* the film was nominated for a Saturn Award, citing it as one of the Best Genre Television Series of that year. The award was a collective nod to the entire film crew— including writers and directors. It verified the fact that the story was welcomed and its experts who came together to construct it were on the right track. As a next vision into Norman Bates' life, it did the job with excellence. Though some technical issues were brought to light by critics, they couldn't argue with 10-million viewers who were still interested in Psycho.

Universal Studios Home Entertainment released the film as part of their DVD selection to Region 1. Region 1 includes the United States and Canada. It has also been a part of their selected releases throughout the entire world since. In 2016, Shout! Factory released *Psycho IV: The Beginning* on Blu-ray to the public under their Scream Factory division. Although the story isn't one of the best sellers to this day, it still is a commonly known tale and included on lists of best horror films of the 90s. The very fact that the tale has its own mythology and structure is enough to keep generations after generations interested and coming back for more.

The house and motel would remain at Universal Orlando until 1998 when they were torn down to make way for an expansion to the park's kid's area. Both sets would be used during the day as great photo opportunity for guests visiting the theme park. In 1992 Universal would revive the Halloween party concept from Hollywood's 1986 event, now entitled *Fright Nights*. The event would use the sets for a *Beetlejuice* show during this first year and then in 1993 and 1994 they would extend the motel for use as a house during the newly entitled *Halloween Horror Nights*. After the sets were demolished in 1998, the event would create

their own haunted houses based on the franchise in 1999 and 2006. The theme park would also open with an attraction that featured the franchise, *Alfred Hitchcock: The Art of Making Movies*. The attraction would have a portion hosted by Anthony Perkins (via recorded video) and would see park guests get their chance to star in their very own shower scene. The attraction would last until 2003 when it was retired to make way for a 4D show about the movie *Shrek*.

The story of Norman Bates in *Psycho IV: The Beginning* truly was a new start. Not only did it show where he came from and give history on mother, but it also gave a future to Norman. He seemingly rid himself of his demons by burning the Bates' house and can move on with a pregnant wife and new life. Rumors swirled some months after the production that Universal was keen to green-light a further installment to the franchise, a movie that focused on Norman Bates Jnr., the said fetus mentioned in the movie (Note: Universal had commissioned three different scripts for a follow-up movie). Whether it was Perkins' untimely death in 1992 or other subdued ratings, whatever the reason another actor would soon take up the mantle but not within the canon of the original.

The Remake

The *Psycho* remake of 1998 was the result of a story that was intriguing enough to last for decades. Norman Bates was the center of the film and as portrayed by Vince Vaughn, he took on the same boy-next-door sheepishness he was at the time known for. Underneath, of course he was much more than an innocent motel owner. He was a killer. What made the story so captivating was his involvement with "mother", who he blames for the killings in his wake. Of course, the audience finds out later that mother has long been gone but he has kept her alive in his mind and through creative taxidermy. As with all *Psycho* pictures we are left with questions, but for this, no greater question can be than 'why was this picture ever made'? Here is the story of the 1998 remake of *Psycho* and how it came to be.

The Cast

Upon release there was a lot of buzz about *Psycho*. The film had its own legacy and its own interest, as former releases had created. This one was even more interesting because of the big-name stars who would be portraying the title characters. Namely, Vince Vaughn, Anne Heche and Julianne Moore were cited. Vaughn had many successes behind him at the time. He began his career with *Swingers* a comedy-drama that was iconic in its own right and

generation. He also moved on to such hits as *Old School, Wedding Crashers* and *The Lost World: Jurassic Park.* Tobey Maguire, Christian Bale, Robert Sean Leonard, Jeremy Davies, Henry Thomas and Joaquin Phoenix were all considered for the role of Norman. Thomas was particularly keen having previously played Bates as a teenager in *Psycho IV*. By taking on the role formerly portrayed by Anthony Perkins, Vaughn's "Norman Bates" was harsher. One of the main characteristics of Perkin's portrayal was Norman's boy-next-door innocent charm. Vaughn didn't translate it the same way; rather, he put a more sinister undertone to the character. Possibly it was his decided veer away from his more comedic roles of the past, but his portrayal was darker. It played to the film because of Moore's increased intensity with her character also.

Julianne Moore was the next big name star who signed on to the Van Sant *Psycho* production. She also was a well-known box office hit as an actor. Unlike Vaughn, Moore had some history with the horror genre. She starred in the 1992 production *The Hand That Rocks the Cradle* and the 1995 film *Safe*. Both films explored the horror genre, though from different vantage points. Beyond horror though, Moore had a solid career in movies as a leading actress. She also starred in *Nine Months, Boogie Nights* and *The Big Lebowski*. By far Moore was one of, if not the, biggest star in the *Psycho* remake.

Her portrayal of Lila was indicative of her experience as an actress and most likely was the reason why Van Sant let her create the character as she deemed appropriate. In an interview, Moore stated that she put herself into her character and asked herself "What would I do if my sister were missing?" By framing the character this way she was able to channel a more direct and forceful Lila.

Finally, Anne Heche was tapped for the role of Marion Crane. She was known for her work on the daytime soap

opera *Another World* but then transitioned into movies with success. Her most notable role prior to *Psycho* was in *Donnie Brasco* as Johnny Depp's wife. From there she moved to roles in *I Know What You Did Last Summer* and *Wag the Dog*. She was cast as the Marion Crane character primarily however for her looks being similar to Janet Leigh's. Heche also played the character very true to the original portrayal, which may have been due to her role being smaller as Marion is killed early in the film. In addition, she was the central figure of the iconic "shower scene" so keeping her character true to the original was important to her.

On top of the three top stars, 1998's *Psycho* also featured other known stars such as Viggo Mortensen as Sam Loomis, who would go onto the *Lord of the Rings* trilogy as Aragorn. It also starred William H. Macy as PI Milton Arbogast who goes in search of the missing Marion. Macy was fresh off his own successes with *Pleasantville, Boogie Nights and Mr. Holland's Opus*. For the most part the prime players were already well known in the movie industry. By choosing them, Van Sant was able to capitalize on their name value to draw at the box office. They were able to work with a director who had made a very solid name for himself in Hollywood with his prior directorial work. The couplings worked well because of the creative license the director would give to each of the players. Though they were to work off of the same script as the original, they were given the opportunity to deliver their lines in their own desired method. This allowed them freedom to interpret their characters with a new vision.

Plot

The plot of *Psycho* starts off with a woman named Marion Crane driving in her car. The backstory is her employer gave her $400,000 to make a deposit for him and instead Crane sees the opportunity to steal the money. Her intention is to

give it to her boyfriend Sam Loomis, to aid him in getting out of his personal financial debt. With the cash in her vehicle, she decides to drive to Phoenix. While on the way to her destination, she grows weary and pulls to the side of the road to take a nap. A highway officer knocks on her car window and when she is suspicious in nature, he decides to follow her. Later she drives to a car dealership to purchase a different vehicle. She then returns to her travels in the new car but doesn't realize the highway officer is still following her. Due to a heavy storm, she decides to find a place to spend the night rather than drive all night. She happens upon Bates Motel.

When she gets to the Bates Motel she meets Norman Bates, the title character. He informs her that he is surprised she came upon the motel. With the new interstate highway, he tells her he rarely has customers. He also mentions that he lives with Norma, his mother, in the large ominous house overlooking their motel. He asks Marion to have dinner with him in the house that night. As they sit down, Marion hears Norman having an argument with mother who is upset that her son invited a woman to dinner. At dinner Marion suggests that Norman put his mother in a facility where she can be more appropriately cared for. He tells her that he has considered it but doesn't want to seem like he's abandoning his mother. When Marion goes to her room for the night, Norman watches her through a peephole carved in his office's wall.

During the night Marion considers her situation and decides that rather than continue her plan to abscond with the funds, she will return it. Using paper and pen, she calculates how much she's spent of the funds and comes up with a plan to repay it to her former employer. She flushes the piece of paper down the toilet when she's done and proceeds to take a shower. While in the shower a woman-like figure appears in the bathroom and kills Marion with a knife. Norman stumbles upon her body and quickly cleans it up. He wraps

her body in the bloodied shower curtain, packs her things together with the remaining cash in the trunk of her car and sinks it in the local swamp.

The story continues as Sam is contacted by a private investigator named Milton Arbogast. He has been hired by Marion's former employer to find her and the stolen cash. Sam also receives a call from Lila, Marion's sister wondering where the now-missing woman is. Arbogast manages to trace Marion's steps to the Bates Motel where he questions Norman. Norman tells him that she stayed just one night and then was on her way. He also tells the private investigator that his mother is feeling ill and cannot talk to him. Arbogast is not satisfied with not being able to talk to Norma, however and plans on finding a way to the mother. He updates Lila by phone and tells her he'll call her again when he finds, and interviews, mother. He secretly enters the house but upon reaching the top of the stairs is attacked and killed by a woman-like figure. When Lila doesn't hear anything back from him, she enlists Sam's help and they call the local police department.

Lila calls Deputy Sherriff Al Chambers. When he hears the story of what Arbogast told her, he is surprised when he hears about "mother". He tells Lila that Norman's mother has been dead for more than 10 years. At the same time, Norman at the house and he is heard arguing with mother telling her to hide in the cellar. She refuses but he picks her up and carries her there against her will.

When Sam and Lila reach the Bates Motel they lie and say they are married. Their goal is to check in and search Marion's room for clues to her disappearance. When they get to her room, the see a piece of paper floating in the toilet. Pulling it out, they find that it has Marion's writing on it and her calculations on the money and how to repay it. Sam distracts Norman so that Lila can get into the house in back to find mother and talk to her. Sam tells Norman that

he believes Norman killed Marion, stole her money and is going to use it to buy another motel. Norman realizes that Lila is gone and he attacks Sam with a golf club, knocking him unconscious. Lila sees Norman coming to the house and rushes to the cellar to hide. There she finds mother's body, which is obviously long-dead. Norman creeps up to Lila, dressed in mother's clothing, to kill her. Sam, who has regained consciousness, fights off Norman with Lila's help.

Norman is arrested but Sam and Lila discuss his case with forensic psychiatrist Dr. Simon Richmond. Dr. Richmond tells them that though mother is dead, she is very much alive in Norman's mind and he has adopted her as an alternative personality. The doctor also tells them that when Norman's real father died, his mother found a new husband. This pushed Norman over the edge and he murdered both her and her new lover. He also took the body, preserved it and kept it around in the house, believing her to still communicate with him through it. Norman believes that mother has committed all the crimes he committed—including murder—and that he was just trying to cover it up to protect her. Dr. Richmond concludes that Norman is no longer in existence and that mother has taken control of his complete personality. Norman, in no uncertain terms, no longer exists.

For the final scene, Norman is in a cell. With a voice-over that is startling and chilling he begins to explain that mother is not capable of doing anything violent. In fact, she wouldn't even hurt a fly. A few final frames show Marion's car being dragged out of the swamp and the movie is over.

> Dr. Fred Simon: Like I said... the mother... Now to understand it the way I understood it, hearing it from the mother... that is, from the mother half of Norman's mind... you have to go back ten years, to the time when Norman murdered his mother and her lover. Now he was already dangerously disturbed,

*had been ever since his father died. His mother was
a clinging, demanding woman, and for years the two
of them lived as if there was no one else in the
world. Then she met a man... and it seemed to
Norman that she 'threw him over' for this man. Now
that pushed him over the line and he killed 'em both.
Matricide is probably the most unbearable crime of
all... most unbearable to the son who commits it. So
he had to erase the crime, at least in his own mind.
He stole her corpse. A weighted coffin was buried.
He hid the body in the fruit cellar. Even treated it to
keep it as well as it would keep. And that still wasn't
enough. She was there! But she was a corpse. So he
began to think and speak for her, give her half his
time, so to speak. At times he could be both
personalities, carry on conversations. At other times,
the mother half took over completely. Now he was
never all Norman, but he was often only mother.
And because he was so pathologically jealous of her,
he assumed that she was jealous of him. Therefore, if
he felt a strong attraction to any other woman, the
mother side of him would go wild.*

[Points finger at Lila Crane]

*Dr. Fred Simon: When he met your sister, he was
touched by her... aroused by her. He wanted her.
That set off the 'jealous mother' and 'mother killed
the girl'! Now after the murder, Norman returned as
if from a deep sleep. And like a dutiful son, covered
up all traces of the crime he was convinced his
mother had committed!*

Production

What made *Psycho* of 1998 so unique was the film maker's
dedication to the original legacy of the story. The movie was
directed by Gus Van Sant. Van Sant was already a big name

in the directorial world at the time. He was not however a name within the horror genre. He had originally gained prestige for himself as a director thanks to hits such as *Drugstore Cowboy* and *My Own Private Idaho*. Both films helped to solidify him in the world of the most innovative and gifted directors of Hollywood. Artistically speaking, he was at the top of the list of directors able to showcase a story in a unique and evocative way.

At the time what Van Sant did not have though was mainstream acceptance. He had formerly focused on indie films and though he gained much accolades for them, he never was considered a "big studio" director. It wasn't until 1997 that he finally made his move to mainstream with the hit film *Good Will Hunting*. The film starred Matt Damon and Ben Affleck and was nominated for nine Academy Awards that year, including a nod for Best Director. With the mainstream success finally in his hands, Van Sant was at liberty to make some of his own calls in terms of what projects he was allowed to work on. Because of the hubbub about *Good Will Hunting* he was given the reins at directing the Alfred Hitchcock remake to *Psycho*. What was anticipated was that he would be able to create an artistic nod to the director, but with his own spin on the story.

> *"It felt a little trippy, I held my purse the same way Janet Leigh did, I walked the way she did, I behaved the same way she did. The whole experience was a mind trip. After dailies each day, I'd say to Gus, 'This is getting weirder and weirder!'"*

> Anne Heche

When Van Sant took over the *Psycho* project, he made some controversial initial decisions with the story. Universal had long held control over the story, having introduced it successfully in many iterations in the past. Giving control to a director was not to be taken lightly. When Van Sant took

over the new project, he immediately decided to make it a shot-by-shot film harkening back to the original production; when he was asked by a reporter as to why he would chose to do this, he replied: *"so no one else has to"*. This was formerly unheard of with the norm being, a director re-inventing a movie for his own storytelling purposes. Van Sant was committed to it staying true to the original. What he did do however was take some liberties. For example, the movie would be shot in color, which was different. It also would include some of the biggest and most established names in Hollywood. What these three decisions did for the film pre-production was create a buzz. Another ambition of Van Sant's was to improve on the original where technical innovation had improved since the original; one such example was the long tracking shot at the start of the movie. Hitchcock had intended for it to be one continuous shot but lacked the technology to do it, Van Sant ensured notes like this was incorporated in an effort to make the audience feel that if Hitchcock was alive today, this would be the picture he would make. Everyone was anticipating what famed director Gus Van Sant would do with the new film and getting tidbits on his changes definitely peaked curiosities for months prior to the release.

One ironic addition was Van Sant occupying the same cameo space as the original with an actor portraying Hitchcock. In the scene it appears as though Van Sant is arguing with the cowboy hated man, when in fact Van Sant wanted to show Hitchcock scalding the director who daring to touch his masterpiece. It wasn't just the faux Hitchcock that wasn't impressed with the remake either, so too was his daughter Patricia Hitchcock O'Connell. At the time the then 70 year old former actress was invited to the set to see the production in full swing who was accompanied to the set with her various daughters and granddaughters all of whom bore an resemblance to the most recognizable member of their family.

167

When she arrived, Van Sant and Anne Heche, were filming the same real estate-office scene in which Pat had appeared in the original. She was treated with welcome praise, no doubt because the crew felt that their controversial project needed an endorsement from the original director's family. But as Van Sant escorted Patricia around the set, the tour came to an abrupt end when she spotted a certain familiar extra. The actor in full makeup who was due to play the Hitchcock cameo was standing outside the window. Patricia was rumored to have taken one look at the actor and then stormed off the set.

"If you think Pat was shocked, you should have seen the look on my face, it wasn't very tactful of us, although in a way, it's something Hitchcock, a notorious practical joker, would've done, isn't it--introducing his daughter to someone dressed up like her father?" Van Sant said at the time. The family would however later endorse the movie:

"I was told that Van Sant is a big fan of my grandpa's and he was interested in doing 'Psycho' to expose a classic film to a younger generation that won't go see black-and-white films. (Hitchcock) Grandpa directed a second version of his 1934 film The Man Who Knew Too Much." Said Patricia's granddaughter Katie O'Connell.

What was interesting about the film was that Van Sant gave his actors some liberties too. They were able to decide whether or not they wanted to stay 100-percent true to the original or to veer off with their own interpretation of the characters they portrayed. For example, Heche and Macy both opted to stay true to the Hitchcock film. They wanted their characters, Marion and Arbogast, respectively, to follow the same mannerisms, script lines and nuances of original actors Janet Leigh and Martin Balsam. On the other hand stars Vince Vaughn and Julianne Moore decided to create their own spin on the characters they were playing— Norman and Lila, respectively. What the actors stated during

press junkets was that they appreciated Van Sant's respect for their vision as actors and his desire to incorporate it into the production.

Anyone who purchases the DVD of *Psycho* from 1998 can listen first-hand to the choices made. The commentary includes Van Sant himself reflecting on the decisions and debates that were first carried out pre-production. He stated that the decisions each individual actor made was first fleshed out in a round-table about the movie. They discussed the choices and which ones the actors felt most comfortable with. Part of the differing visions were a result of Van Sant and his reputation for being a highly artistic director with depth to his movies. It gave the actors the right playground to truly test their own artistic abilities with their characters. What Van Sant confirmed with the commentary was that the only character in earlier iterations who was completely defined was the star, Norman. He had a legacy of being the same psycho-killer mama's-boy who looked innocently sheepish. He was continuously explored—both his impetus for kills and his inner struggles. The other characters were never fleshed out however. They were left to interpretation by the audience; the audience was able to "fill in the holes" of their personalities. Van Sant noted this and gave his cast of professionals the ability to fill in their own holes of character portrayals. They were given the trust to paint the picture of each character as they saw fit. It made for an interesting result, with combinations of old well-known characters and characters with new attitudes.

One major change was Moore's presentation of Lila, Marion's sister. Her character was decidedly more assertive than the character that was originally created. Lila is seen as almost an antagonist as she hunts down information on her missing sister. While earlier Lila was a soft woman troubled over her sibling, Moore's character is threatening and direct. Again- Van Sant gave the actors license to do their own portrayals as they saw fit. Moore took advantage of the

broken rule and let her own creativity run wild.

The 1998 *Psycho* was also updated in terms of logic. You can see in the film that the amount that Marion steals from her employer is much more than it was in earlier versions. Originally it was only $40,000 and this time around for the 90s it was elevated to $400,000. Also, the hotel room cost was noted to be similar to market standards, as was the new vehicle purchased by Marion at the beginning of the film. The clothing within the film also was updated. It was reported that the costume designer Beatrix Aruna Pasztor believed that pieces from the 60s would be most appropriate. In fact, she even started procuring pieces as she saw fit. Van Sant immediately updated her however to tell her that this film from 1990 would be true to modern-day.

Van Sant also confirmed in the director's commentary that he shortened some scenes. Namely, the one at the end where Dr. Richmond is talking about Norman and his condition. Van Sant stated that it was decidedly cut down to make it more accessible to the current audience who would be watching. He recognized that the new generation of 20-

to 30-somethings would appreciate the chance to do their own interpretation of the film and Norman. Rather than telling them what the official diagnosis was, the director opted to let the audience make the call.

> Norman Bates' Mother: It is sad when a mother has to speak the words that condemn her own son. I can't allow them to think I would commit murder. They'll put him away now as I should have years ago. He was always bad and in the end he intended to tell them I killed those girls and that man, as if I could do anything but just sit and stare like one of his stuffed birds. They know I can't move a finger and I want to just sit here and be quiet just in case they suspect me. They're probably watching me. Well, let them. Let them see what kind of a person I am. I'm not even going to swat that fly. I hope they are watching... they'll see. They'll see and they'll know, and they'll say, "Why, she wouldn't even harm a fly..."

Soundtrack

Sound was something that the *Psycho* story was built on. Just think of the iconic "shower scene" where Marion meets her untimely fate. Think of the slicing music as juxtaposed against the actual knife stabs that kill her. Without the harsh and almost irritating sounds, the scene would have not been as harsh. Harsh was its intent. With the 1998 remake, music was used in the same manner—to accentuate the scenery and convey a feeling within the watcher.

For the most part the soundtrack was kept in its original form. The skeletal formation was translated to the remake by popular soundtrack master Danny Elfman. Elfman has been instrumental in creating music for numerous iconic television shows and movies including *The Simpsons* theme song, *Avengers: Age of Ultron* and *Pee-wee's Big Adventure*.

171

He also composed the score for Cirque du Soliel's "Iris".

Elfman used the original score as created in 1960 by Bernard Herrman. He worked with sound to update some of the backing sounds and rearrange them. In addition, he added songs that contributed to the horror theme of the movie. He tapped into songs that were written with the word "psycho" in them and songs relating to death. One notable addition was Rob Zombie's "Living Dead Girl". The entire soundtrack is notably dark, which is appropriate to the genre and message of the movie.

Reception

Despite its well-known and well-respected director and all-star cast, the movie was not well received by critics or audiences. What hurt Van Sant the most was his decision to make it a shot-by-shot remake. Critics everywhere concluded that for a film to be successful remake, it has to be "re-made" rather than duplicated. They also noted that a shot-by-shot remake is "pointless" and contributes nothing to the directorial evolution that a remake is predicated on.

Even the acting was in question. One critic noted that Heche's performance was startlingly weak despite being a word-for-word iteration of the preceding performance. They noted that despite delivery of the same lines, the character birthed had a completely different tone. Vaughn was also targeted by critics. They noted that the Norman Bates character was formerly successful as a draw because of his delivery as a sneaky character rife with double-entendres in dialogue. Vaughn opted for a more direct and cunning delivery that didn't necessarily work for the legacy.

For the most part the film was deemed a "flop" critically and the same was said for its financial showing. It earned just over $21-million in the US and just over $37-million worldwide. With a production budget of roughly $60-

million, the movie barely broke even. It earned many different "worst" awards including "Worst Remake" from the Golden Raspberry Awards and "Worst Actress" for Heche. By far the film never earned the accolades its reputation suggested with the director and cast. Despite this though, Van Sant continued to defend his production stating that it was an experiment in filmography and never meant to be a box-office smash.

The 1998 remake of *Psycho* came to the market with a lot of buzz. The iconic director and star-studded cast was thought to be enough to create a smashingly successful box office. Despite hopes, it never reached that level of success. It was an example though of how the same script, the same characters, the same shots and technological camera work don't necessarily convey the same message. Perhaps it was the actors and their collective interaction that changed the outcome. As a film, if it is viewed as a stand-alone project, it still has some viable artistic value and is an important contribution to the legacy of Norman Bates.

Two years after the release of the picture, Universal celebrated the 40th anniversary of the original movie with a series of DVD releases and special programs on TCM. They held a competition entitled the 'Best Psycho Shower Scene Scream' which was judged by Janet Leigh from the original picture and was won by Sue Pelinski. Pelinski's prize? To become the second person to ever have a shower at the infamous motel, which she did to a gathering of journalists and Leigh on July 26th of that year. Other than this subdued celebration, no further buzz or entries into the *Psycho* franchise were seen until more than a decade later when the franchise would be picked up, dusted off and be totally overhauled into a new direction entirely.

The TV Series

In 2013 a new television series entered the A&E playlist - the *Bates Motel*. It followed the story of the iconic Norman Bates character and his oedipal relationship with "mother". The story capitalized on the remaining interest the audience had with Norman and his odd tie to his matriarch. What has been true since 1960 is that people love to see what makes him tick. Possibly it was the juxtaposition of a boy-next-door type to a killer that piqued interest. Or, maybe it was the delivery of the title actors who portrayed the character. Regardless, the audience loves to watch the development of Norman and how he navigates through life with his off-center viewpoint.

It was actually not the first property to bear the name *Bates Motel*; there was actually another property back in 1987 that already used this name. *Bates Motel* was a 1987 American made-for-television comedy-drama come horror film that was a spin-off of the original *Psycho* film series. It was produced by Ken Topolsky, written and directed by Richard Rothstein, and starring Bud Cort, Lori Petty, Moses Gunn, Gregg Henry, Jason Bateman, and Kerrie Keane. The film premiered on July 5th, 1987 to mixed reviews. This TV movie follows Alex West, a character who inherits the house and motel from a now deceased Bates; it has no connection to the 2013 to 2017 series of *Bates Motel,* just the same name.

Within the horror genre nothing has been quite as poignant and attention-grabbing as the story of *Psycho* and its star Norman Bates. Though villains have come and gone, few have incited the amount of interest as the character. There are a few things about Norman that are central to his persona:

- Norman is charming with boy-next-door looks
- He is a businessman, assimilating into the world around him like a "normal" person
- He has a special bond with his mother
- He is a secret serial killer

One by one each of these characteristics may not have been quite as chilling; put together, however, they make one protagonist that is one of the most captivating villains of all time. Of course Norman takes some of his persona from the real world and some of his persona is completely fictional. Here is the story of the *Bates Motel* TV series and how it came to be.

Development

The lasting interest in Norman Bates' life has gone on for decades. This television series was another ode to mental illness, violence, crime and total insanity. The series was first announced on January 12, 2012 and it was released as a prequel to the total legacy of the Bates' series. What made it captivating was the first-hand view into the life of Norman from the time he was a teenager. Over the decades, he has been a hot topic of conversation due to his infatuation with mother. Of course what was so enticing about him was that relationship. Originally, the character was based on two different ideas:

A&E announced in January of 2012 that the story would be retold as through the television screen. The goal was to tell the audiences how Norman became a man. The tale was

given to writer Anthony Cipriano to script and he took liberties to fill in all the holes the story still had. Though he began his work on the Rosie O'Donnell Show, he soon was welcomed into the horror-writing field because of his obvious penchant for storytelling.

Adding to the excellence of the series would be famed screenwriter and producer Carlton Cuse. Cuse was known for pioneering the storytelling pathway in a variety of television series. He worked on *The Adventures of Brisco County, Jr.*, *Nash Bridges* and of course the huge hit, *Lost*. With a solidified history of successful productions, Cuse was tasked with retelling Norman's story from his teen years. In addition to Cuse, Roy Lee, Vera Farmiga, Tucker Gates and Kerry Ehrin took the helm at executive production. Cuse once stated that *Twin Peaks* was their initial inspiration for this project. On July 2nd, 2012, A&E bought the project and ordered the series.

Casting

One of the key elements of a successful production is finding the right cast to portray the central characters. The first one on board for the *Bates Motel* was Vera Farmiga, who already was committed to being one of the executive producers of the series. She was announced as taking on the role of "mother" in August of 2012. At that time she had already finished *15 Minutes*, *The Manchurian Candidate* and *The Boy in the Striped Pajamas*. She had a well-established acting career and had earned plenty of accolades for her work. As Norman's mother Norma, Farmiga had to be able to portray a kind woman with a sinister depth to her. The question that was always on people's minds was: If mother was so horrible, why would Norman gain such an attraction to her? Why would he work so hard to please her if she was thoroughly a horrible woman? The answer came to people viewing the series. They cast a mother who was kind and realistically, viewers could see how Norman would be taken

with her. From the first few moments of the series though, when she helps to kill and hide a body, audiences knew that there was much more to her than just being a "nice" mother. Like Norman she had the "wolf in sheep's clothing" persona. Farmiga, a talented actress knew how to portray the character with the nuances of violence and hate.

Next, the role of Norman Bates was cast and went to actor Freddie Highmore. He is an English actor who started his career with 1999's *Women Talking Dirty* and found success with the hit remake of *Charlie and the Chocolate Factory* and *The Art of Getting By*. Interestingly enough, Highmore was lesser known in the US however captured a nomination for the Critics' Choice TV Award for Best Actor in a Drama Series two years in a row for his portrayal of Norman. Most likely what won him the role, beyond his acting ability, was his look. Highmore had stared in *Charlie and the Chocolate Factory* as the lead role of Charlie Bucket. The role was built on Charlie's innocence and pure heart throughout life. Seeing his ability to portray an innocent character made him a true candidate for the role of Norman Bates as a teenager. Remember that Norman was a serial killer but subtle with his violence. Whomever took over the role had to possess the ability to temper the anger and rage within the title character. What is true of both the Norman and Norma characters is that they had to possess a thin layer of likeability to them with their serial killer personas rushing just beneath the surface.

On top of the two title roles, casting added Max Thieriot as Dylan Massett, Norma's estranged other son who returns to live at the Bates' house. Though his character was never was mentioned before, he added the perfect foil to Norman's possessiveness over their mother. The two have differing plotlines that cross periodically. For the most part Dylan is by himself though, struggling with his own demons, namely finding the true identity of his father and what happened to him.

Olivia Cooke took on the role of Emma Decody. Cooke was a staple in the young horror genre of film, having already started in *The Signal*, *The Quiet Ones* and Ouija. As much as Jamie Lee Curtis held the title of "scream queen" back in the 80s, Cooke took the title on in the mid-2010s. She conveyed the innocent one who falls into some dark force. Her expertise with the genre is what made her the perfect person to portray Emma Decody. The only issue she had was her accent. Having been born and raised in Manchester, she had a thick English accent to contend with. She won the role by sending in her own audition tape and within three weeks, she had the part. To rid herself of her accent, she worked with fellow-Brit Highmore, who had learned how to lose his accent already. Her role as Emma Decody was the first American role she won.

Playing Sheriff Alex Romero was Nestor Carbonell, who had gained a following already with his extensive television and movie work. He started his career on *As the World Turns* an iconic soap opera and quickly moved on to a long list of projects including *A Different World*, *Suddenly Susan*, *Ally McBeal* and *Monk*. Possibly his most notable role was as Richard Alpert on "Lost". The Bates Motel project brought him together once again with *Lost* creator Carlton Cuse. Carbonell had extensive experience when he garnered the role and knew how to effectively portray his character. Initially he was brought to the *Bates Motel* as a recurring character, however after season one he became a main character. As Sheriff Romero he plays the one hot on the killer's heels—not knowing that it is Norman but having his own suspicions.

Nicola Peltz was tapped to play Bradley Martin in the series. Her role is the love interest for Norman Bates as a teenager. The relationship is an interesting one because of his infatuation with his own mother and her disdain for any female relationships Norman might try to pursue. Of course, her son is a normal teen boy who is interested in girls, but

believes that liking women is "wrong" as mother drilled into her son's psyche for many years. In later years you can hear Norman arguing with "mother" as they debate the issue of dating a woman who is far sub-par for her son. Of course throughout his lifetime, Norman likes a few women, but regularly treats liking the opposite sex as a "bad" thing that needs to be repressed. After all, mother would never approve.

The casting of *Bates Motel* was a streamlined process because of the definitive character profiles involved. The story was long told so it was clear what direction the basic storyline would move in. Norman was the star. The story was a retelling of how he became a serial killer and how mother played into that development. The ancillary characters push the story along to make sense of the descent into madness that Norman goes through.

Filming

Filming the series was exciting. Unlike movie iterations, this was a series, which meant that it would require in-depth exploration of each character and their motivations. It gave actors the rite to develop their own vantage point to contribute to the entire story. Picking a location, A&E eventually decided on Aldergrove, British Columbia, near Vancouver. This was the central location for filming, with some additional scenes throughout the area of Fraser Valley. Canada was chosen for filming due to the fact the original house is still an ingrained addition of the now world famous Universal backlot tour and as such they felt production would be compromised if the Hollywood sets were used.

> *"I feel incredibly lucky to take on such an iconic character, we know where Norman Bates is going to arrive and it's interesting to see how he arrives there."*

> Freddie Highmore, Norman Bates

What made the location so popular with A&E executives and the executive producers was its urban-feel but still abundance of nature within. The area is not incorporated even though it is sometimes referred to as one. Aldergrove is the backdrop of the series, although in the show the town is called "White Pine Bay" and set in Oregon. Though the original Bates home is still at Universal Studios in California,

there was a replica set in Aldergrove for filming. The house is located on 272nd street and a popular tourist location for fans visiting and locals. It is a definite talking piece for the town. What better visitor attraction than the home that Norman Bates grew up in?

Season 1

The show first aired in March of 2013. The story picks up six months after Norman's father dies. Norman and his mother relocate to the fictional town of White Pine Bay, Oregon where they purchase a new motel to manage together. One night Norman sneaks out of the house to meet up with Bradley, his love interest in the show. While he is gone, the former owner of that motel Keith Summers violently breaks into the home and rapes Norma. Her son walks in and attacks Keith. Norma ends up killing him. The two—mother and son—then hide the body in the harbor and swear each other to secrecy on their first dual murder. Norman quietly keeps Keith's utility belt. The sheriff Alex Romero and his deputy Zack Shelby come to investigate but find nothing. With a missing man to find, they leave however are intent on finding some evidence to his whereabouts.

Norman in the meantime carries on his life as a normal teenaged boy. He has a friend Emma Cody, who is strictly platonic in involvement. He also has Bradley who he is romantically interested in. Of course Emma has a crush on Norman and the relationships are explored periodically. The culmination is a dance where Norman attends with Emma but keeps looking at Bradley and her boyfriend. Emma notices his interest and ends up leaving. He piques the interest of Bradley's boyfriend who punches him. Miss Watson, the school's English teacher, ends up helping Norman and his injuries. She takes him home with her and as she is changing, Norman convinces himself that his teacher is trying to seduce him. The closing shot is of her corpse as Norman goes home.

"Look, it's a great hook. For me, yeah, I kind of groan at remakes and the like. But, hey, theater is the gathering of shoplifters. Hitchcock has stolen from Shakespeare. Shakespeare borrowed from Plutarch. Stories are recycled constantly. That's not to say initially when I heard the title, I didn't roll my eyes. But with the first flip of the script, I was just lost in it."

Vera Farmiga, Norma Bates

During the run of the first season the movie *Hitchcock* was released by Fox Searchlight. It was a biographical production based on Hitchcock's obsession in creating the original *Psycho* movie. The good director was portrayed by Anthony Hopkins. It documents his passion for the project along with his relationships with the cast, crew and his adoring wife Alma Reville lovingly portrayed by Dame Helen Mirren. Although no cross-promotion was undertaken, it is worth noting this entry into the wider Psycho franchise. It was based on the book, *Alfred Hitchcock and the Making of Psycho* by Stephen Rebello.

Season 2

The second season of *Bates Motel* first aired on March 3rd, 2014, still on A&E. It garnered more than 3-million viewers on its premiere night, making it an official hit for the studio. In this season, Norman's first murder, his English teacher, is explored. It also is an opportunity for Nestor Carbonell's "Sheriff Romero" to make his official entry to the series as a regular. He is the one investigating the death of Miss Watson and pushing for answers.

This is also the season here Norman starts to show true unraveling into madness. It began with Miss Watson's interaction of season 1. He started to hallucinate, which is why he eventually killed her. He has more fits of madness

throughout the season. What the season is mostly comprised of is the exploration of the ancillary characters and their stories. For example, Dylan, Norma's estranged son, returned in season 1 and in this season, he starts searching for answers as to who his real father is.

What is key to the season is the fact that Norman finally admits to Miss Watson's murder by telling his mother. He states however that it was a "dream", though she knows it is true. She tells him to never to tell anyone. Norman takes a gun to the woods to commit suicide. Norma finds him and talks him out of it. Romero is still trying to pin the murder of Miss Watson on someone and continues to find evidence that points to Norman. He has Norman take a polygraph test and Norman passes.

Season 3

The third season is a story that delves deeper into a mother's unconditional love for her child and his growing insanity. Even the picture of the promo poster shows Vera Farmiga lovingly holding her child while Norman flashes a sinister look to camera. The season premiered on March 9th, 2015 and still had the hype it needed to garner 2.1-million viewers.

In this season Norman is entering his senior year and continues to hallucinate. Norma starts homeschooling him because of the episodes. In this season a character named Annika Johnson is introduced and presents as a new love interest for Norman. Of course the love is ill-fated and Annika disappears. Sheriff Romero goes on a hunt to find the missing girl that leads him to a local gentlemen's club. The girl shows up one day but has a gunshot and dies. Just prior to dying, however she manages to hand Norma a USB drive.

The USB and what could be on it is the central focus of this season. After much investigation, Norma finds that

password-protected USB contains a financial ledger that tells of an illegal drug trade going on as managed by the town representatives. Though this is a sign of some conspiracy and cover-up, Norma is more concerned with her son and his mental fragility. Sheriff Romero suspects that Norma is lying to him about a lot—including her husband's death so he distances himself from the family and his investigation.

It was also during this season that the original door from the 1960 Psycho house was found and auctioned-off. Up until recently, it was being used as the front door of the Dallmann Kniewel Funeral Home in Rib Lake, Wisconsin. It sold at the auction in Hollywood for $22,500.

Season 4

In season 4, the popularity of the show continued. Though it wasn't as widespread as former seasons, it still showed respectfully with over 1.5-million viewers at its premier on March 7th, 2016. Though viewership was slightly down, this was the season that garnered three "People's Choice Awards" for Best Cable TV Actress for Formiga, Best Cable TV Actor for Highmore and Best Cable TV Drama for the show.

During this season *Robert Bloch's Psycho: Sanitarium* would be released. Bloch who died in 1994 was not the author, instead it was famed author Chet Williamson who penned the novel in the much loved style of Bloch. Publishers Weekly said:

> *"Horror author Williamson ably succeeds in the tough task of creating a sequel to Robert Bloch's masterpiece, Psycho; a prequel to the less effective Psycho II; and a solid story in its own right...Williamson takes advantage of the 1960s setting to throw in plot lines generally underused in horror (including a subplot around a Holocaust*

survivor), and there are enough twists to keep things moving at a breakneck pace. The novel shines when he focuses on Norman and both his internal struggles with his "Mother" personality and his awkwardness around his newfound sibling. Whenever Norman gets the spotlight, the novel feels like a lost Bloch work."

In this season of *Bates Motel,* the story plays out with Norma's growing concern for Norman's mental health. She also pushes to get him the professional help he needs and sends him to Pineview Hospital, a mental institution. She also begins to turn to Sheriff Romero more for emotional support and the two start to fall in love. In fact, in this season Norma ends up marrying Romero. Of course he moves into their home and has his own past. A former girlfriend starts to show up and express her feelings on his marriage. He tries to quell her and keep his marriage on track.

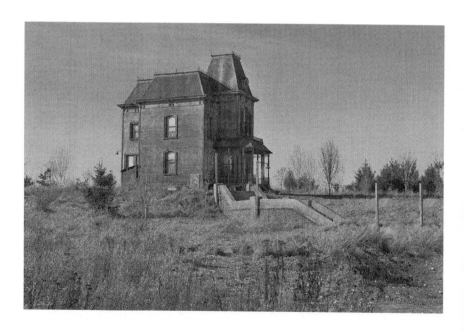

In the meantime, Norman is working on his own sanity with a therapist and intense mental studies. This is where Norman starts to have talks with "mother" when mother isn't even around. He starts hallucinating complete dialogues and interactions with mother. His therapist Dr. Edwards realizes his psychotic breaks. He handles Normal carefully, fearing that he will continue with the hallucinations and they will get dramatically worse.

Despite trying to keep their marriage a secret, Norman eventually finds a newspaper clipping telling him of his mother and Romero's wedding. Romero encourages Norma to give Norman the truth about their relationship. When she discusses it with Norman, he is irate because he was never allowed to have girlfriends, but she got married. Although Norman gets out of Pineview, Romero encourages Norma to re-commit him. Norman eventually closes the vents in the house and lights the furnace in an effort to kill both himself and his mother. Romero finds them and is able to save Norman, but Norma is dead. When Norman is told of her death, he hears music playing and "mother" playing their piano.

Season 5

Season 5 starts off with the death of Norma. Of course she is gone, but Norman is in no way "done" with her. In fact, he believes she is still alive talking to him and interacting with him regularly. Farmiga returns as mother, but is now playing her as a fiction of Norman's mind and not a real person. The season is a true showing of what Norman is capable of. With mother gone, Norman now has violent blackouts and "mother" continues to threaten him. Her goal is to take over his persona completely. Romero is angry and wants revenge on Norman for the murder of his wife.

This season's first premiere episode will air on February 20th, 2017. As with the other seasons, it will have 10 episodes

within and continue to explore Norman and his motivations. Of course now that mother is officially dead, viewers can expect to see Norman as he is directed by her. Here is where he starts to follow orders by "mother" and eventually takes on her personality to commit more murders.

Bates Motel by all accounts was a smashing success. Millions of viewers continue to show up to watch Norman Bates as his new story is told. What is interesting is to watch how he descends into madness as a teenager. The story is rife with controversy, illicit activities, murder, sexual innuendo and insanity. What better way to spend a Monday night?

Season 5 was confirmed as the last season of *Bates Motel*, and that the popular music superstar Rihanna would be playing the part of Marion Crane. Crane is said to appear at the end of this series right where essentially the movie's story started, thus bringing the show full circle. The season will play across television screens throughout 2017, just as news broke late January of that year, that the infamous house and motel set that was purposefully built for the show in Canada was being permanently demolished. And just like the movies and books before them, this show will bring the franchise to a melancholy close but with one glimmer of hope. I am remembered of a quote often paraphrased that despite *Psychos* being wholly unpredictable, I would predict that you can't keep a good *Psycho* down and that "mother" and Norman will some day be back...

Alfred Hitchcock - Host: [signing off]

I hope you'll join us again next week, when we will present you with another story of gripping, spine-tingling suspense, and three boring commercials to take the edge off of it.

Thank you and goodnight!

ABOUT THE AUTHOR

Christopher Ripley was born in the UK but has been traveling to and living in the US for many years. He has been attending both Universal Studios Florida and Hollywood for over 20 years. He authored his first book in 2015, Halloween Horror Nights: The Unofficial Story & Guide, which went on to become a bestseller.

Since then he has setup the popular HHN blog hhnunofficial.com, become a co-presenter of the ScareZone podcast (a dedicated HHN podcast) and Dis After Dark (Europe's most downloaded Florida theme parks podcast), has ghostwritten a number of books, and has other books in the pipeline, all related to film and theme parks.

YOU MAY ALSO LIKE FROM THIS AUTHOR...

16912683R00115

Printed in Poland
by Amazon Fulfillment
Poland Sp. z o.o., Wrocław